BOLTON
THROUGH TIME
Bolton Camera Club

AMBERLEY

First published 2014

Amberley Publishing
The Hill, Stroud, Gloucestershire, GL5 4EP
www.amberley-books.com

Copyright © Bolton Camera Club, 2014

The right of Bolton Camera Club to be identified as the
Author of this work has been asserted in accordance with
the Copyrights, Designs and Patents Act 1988.

ISBN 978 1 4456 1851 7 (print)
ISBN 978 1 4456 1870 8 (ebook)

British Library Cataloguing in Publication Data.
A catalogue record for this book is available from the
British Library.

Typesetting by Amberley Publishing.
Printed in Great Britain.

Introduction

This volume looks at changes that have occurred in what has become the Metropolitan Borough of Bolton, encompassing not only the former County Borough of Bolton but also Horwich, Westhoughton, Farnworth, and the other areas of town and country that comprise the modern borough.

Significant advantage can come from being one of the first in any particular field of enterprise. Bolton and the surrounding towns were early actors in the Industrial Revolution, being well placed with natural resources (especially coal and water), geographical location and the skills of their local people.

Flemish migrants arriving between the fourteenth and seventeenth centuries brought textile weaving skills, and the inventiveness of Richard Arkwright and Samuel Crompton made the mechanisation of textile operations possible. Conditions in Britain were also right for a massive expansion in Bolton's economic activity – centred on cotton spinning – and the engineering companies needed to support that growth. In addition, the associated activities of bleaching, dyeing, machine tools, and boiler manufacture took root, as did railway engineering.

The population of Bolton exploded during the nineteenth century as the economy surged forward. By the early twentieth century, the Bolton area had more than 200 cotton mills, making it one of the most important spinning areas in the world.

However, this growth came at a price – the disadvantage of being an early innovator. The burgeoning growth took place in a climate of minimal local governance and regulation. Housing conditions were often desperate and public squalor was commonplace. Towns expanded, often having little regard for wider public health. Rivers were polluted, land tipped and industrial enterprises made uneasy neighbours.

This then is often the setting for many of the earlier photographs in this volume. At the turn of the twentieth century, when postcards and photographs were becoming commonplace, Bolton and its surrounding towns were thriving, yet largely devoid of trees and vegetation in the tight-knit urban streets. Public parks, often donated by local benefactors, gave relief, but the greening of the urban areas had to wait until later in the twentieth century when the urban fabric loosened up with the closure of many industrial activities and the rise of public-funded slum clearance, derelict land reclamation and tree planting. The change in tree cover is perhaps the most noticeable difference between many of the photographs in this book – a very welcome trend of course.

Today, Bolton is no longer a major textile town, although engineering is still important. Missiles and steel fabrication have replaced railway engineering and cotton spinning. Other modern activities include financial and professional services, bread baking, call centres, retailing and information technology. Bolton is the sixth largest employment centre in the North West, and is largely self-contained for living and working. Many of the changes in Bolton over the years have largely been beneficial, and we hope they are reflected to some degree in this volume.

Ray Jefferson
President, Bolton Camera Club

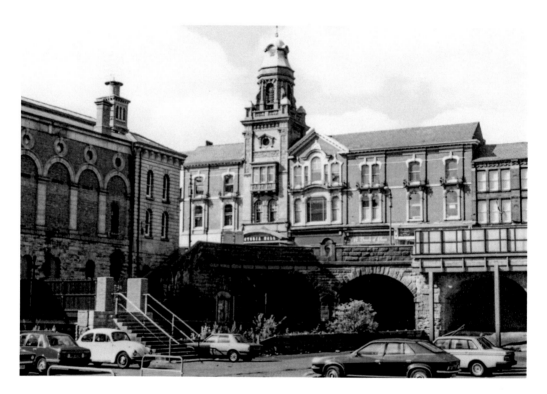

The View Across to Victoria Hall, Knowsley Street

Many Bolton people will have parked their car here, behind the Market Hall, in the 1970s and 1980s. In the 1880s, this was part of a heavily industrialised section of the Croal Valley. On the right would have been Joseph Ormrod's flour mill, and a machine works was to the left. The authorities acquired the power to culvert the river here in 1854, but this was not achieved until the construction of the Market Place over this land after the autumn of 1985. Following an unsuccessful bid for planning permission to redevelop the land in the 1960s, the local authority was obliged to purchase the site, and it wasn't until the late 1970s that renewed interest in providing a retail scheme on the area emerged. The result was the Market Place, containing 230,000 square feet of retail space, by Grosvenor Developments. (*Photograph: Joan Horner*)

Acknowledgements

The creation of this book has been a co-operative enterprise between members of the Bolton Camera Club. However, we could not have done it without significant help from others, who we wish to acknowledge.

We wish to thank Julie Lamara (collections officer in the Bolton History Centre, Bolton Museum and Archives) for her support and interest, as well as Kara Hamer (capital works project manager, Bolton Library and Museum Service), and Erin Beeston and Matthew Watson (collections officers, Bolton Library and Museum Services).

Images marked as 'Bolton Archives' and the artwork on pages 53 and 77 are copyrighted by Bolton Council, from the collections of Bolton Library and Museum Services. Permission to use these images is gratefully acknowledged.

Thanks are also due to Tony Watts for checking proofs, offering helpful comments and giving practical help. Permission to use the photographs of former photographers was kindly given by Margaret Chappell (to use photographs taken by Geoffrey A. Whitehead), Barbara Kitchen (to use photographs by George Sewell) and David Bowtell (to use images by Harold D. Bowtell).

Valuable access to older images and information also came from Margaret Koppens and David Mason of the Halliwell Local History Society, Alan Martland, John Turner, Alan Haworth (engineer on the St Peter's Way project) and Derek Eccles. John Sloane is thanked for access to his personal railway images, as is Geoff Davies for permission to use some of his excellent street photography around Bolton.

Many members of the Bolton Camera Club have provided information or images, old and new, for the book, including Judy Bell, Alan Bromiley, Tracy Calderbank, Sarah Christian, Adrian Drummond-Hill, Phil Durkin, Frank Green, Jeff Griffiths, Gordon Hartley, Mike Hesp, Robert Holden, Joan Horner, Don Isherwood, Ray Jefferson, Daniel Kusnyer, Jeff Layer, Dave Ligett, Paul Longden, Walter Morykin, Neil Pilkington, Diane Ronson, Mick Stone, Peter Thomasson, Richard Towell, Blake Wardle, and Tony Watts.

Every endeavour has been made to identify and contact the copyright holders of the images used and any errors that have occurred are inadvertent. Anyone who has not been contacted is invited to write to the publishers, so that a full acknowledgement may be made in any subsequent edition of this book.

Civic Centre

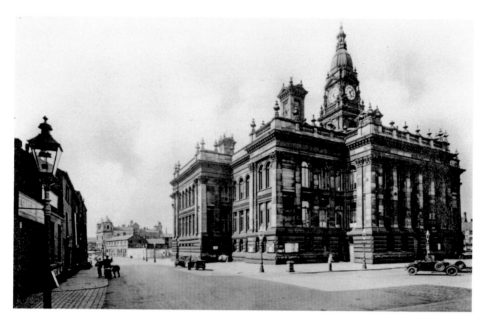

Bolton Town Hall

Bolton Town Hall was originally designed by William Hill of Leeds and George Woodhouse of Bolton. Opened by the Prince of Wales in 1873, it cost £166,418 to build. It had originally been envisaged in part as a job creation project at the time of the American Civil War in 1863, when Bolton suffered from the general shortage of cotton caused by the conflict. However, construction did not begin until 1866. The building was extended in the same style in 1938, as part of a comprehensive civic centre expansion by Bradshaw Gass & Hope. (*Old photograph: Bolton Archives, modern photograph: Ray Jefferson*)

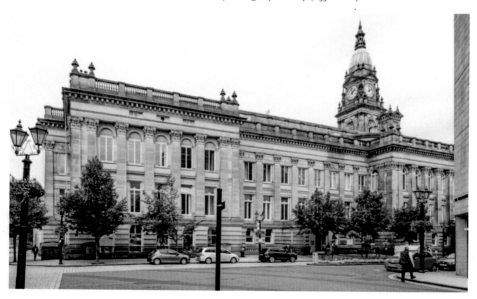

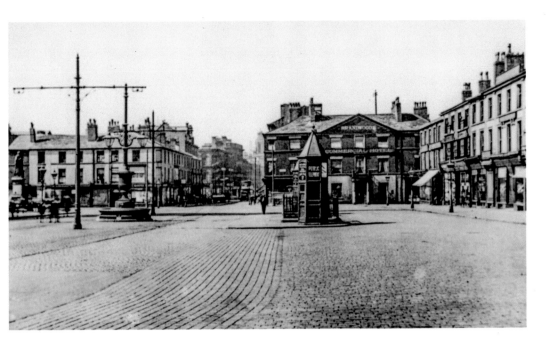

Victoria Square

Benjamin Hick presented the gas lamp, seen to the left in the old photograph, to the town when Victoria Square was completed in the 1820s, which provided a better space for the market than had been enjoyed in Churchgate and Deansgate. Benjamin's son provided the circular trough at the lamp's base. A public drinking fountain was also erected by public subscription. The public telephone, which came later, was offering local calls for 1d. All these were removed in the 1920s to make way for the war memorial, which was designed by Bradshaw Gass & Hope and was unveiled by the Earl of Derby in July 1928. (*Old photograph: Bolton Archives, modern photograph: Alan Bromiley*)

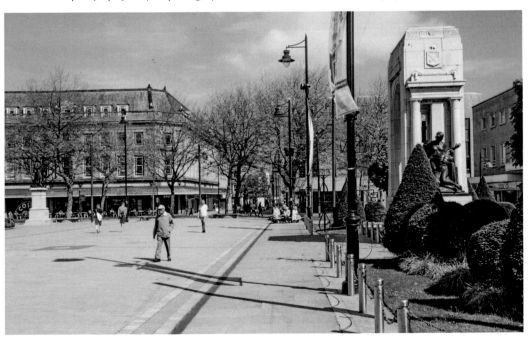

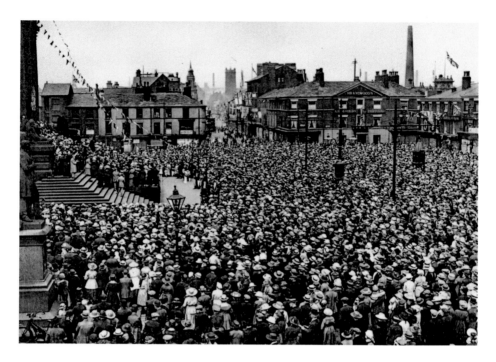

Victoria Square on Peace Day

Although the First World War effectively came to an end for most combatants in November 1918, the treaty negotiations continued until June 1919. Soon after, on 19 July 1919, the nation celebrated on what was known as Peace Day. The old picture makes it clear that the day was well supported in Bolton, although not by everyone – many ex-servicemen were still looking for jobs and did not wish to celebrate the war. Hats were the order of the day, a band is visible on the town hall steps and tram services through the square were suspended. The modern photograph shows the leafy nature of modern Bolton. (*Old photograph: Bolton Archives, modern photograph: Ray Jefferson*)

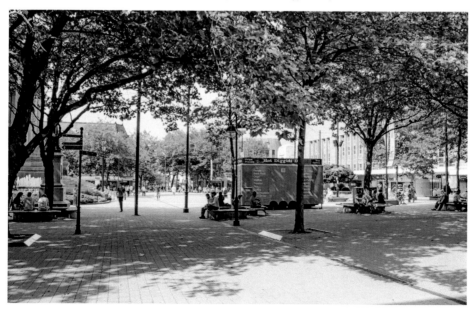

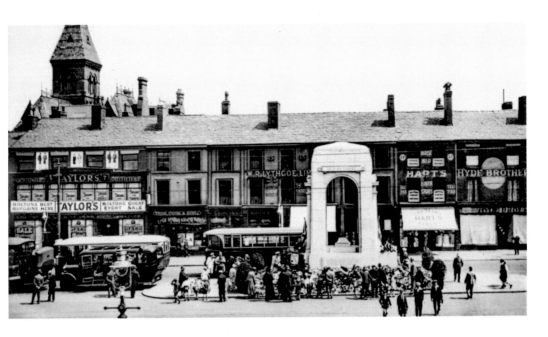

The War Memorial

The crews from the Ribble Motor Services Leyland Lion buses are admiring the war memorial following its unveiling on 4 July 1928. It is clearly summer and the memorial is festooned with floral tributes. The smaller vehicle on the left with its door invitingly open is offering trips to Blackpool for six shillings (30p). The shops in the background include those of Mrs Gertrude Taylor, costumier and ladies outfitter, Lythgoe's wholesale and retail confectioners, and Thomas Cook & Son Ltd, who still have premises in this frontage today as part of Crompton Place. The tower of the gas board office can be seen on the left of the old photograph. (*Old photograph: Bolton Archives, modern photograph: Alan Bromiley*)

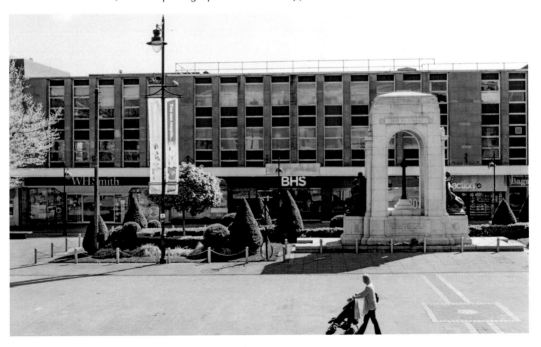

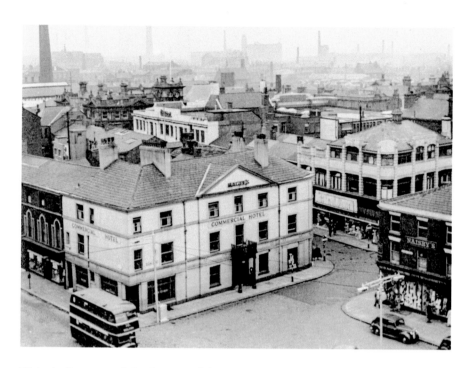

Victoria Square and the Commercial Hotel

The Commercial Hotel, which faced the northern side of Victoria Square, dated back to the late eighteenth century, at which time it enjoyed a fairly rural aspect. It saw many changes in the square during its lifetime, and was used as the headquarters for many local societies. Being close to the town hall, it had a long association with politics. The hotel eventually closed in April 1972 and was demolished the following November to make way for a new Mothercare store. Naisby's drapery shop , visible to the right, closed in 1959, and its site was redeveloped as a preliminary to the later Arndale scheme. (*Old photograph: George Sewell, modern photograph: Neil Pilkington*)

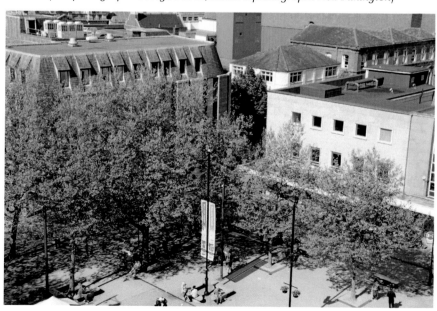

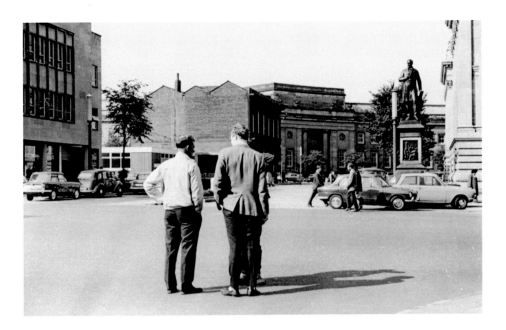

Victoria Square

The men in the older photograph could perhaps be council officers discussing the closure of Victoria Square to traffic. This happened on 31 March 1969. The building beyond the men (No. 67 Victoria Square) opened as a lending library in 1893, and remained as such until the new library opened, in what became Le Mans Crescent, in 1938. A period as the Victoria Restaurant was followed by its use as the library's bibliographic services unit, and as a housing office. The statue is of local benefactor Dr Samuel Chadwick, erected by public subscription in 1873. Among other schemes, he built and endowed the Chadwick Orphanage in Chadwick Street at a cost of £22,000. (*Old photograph: Frank Green, modern photograph: Phil Durkin*)

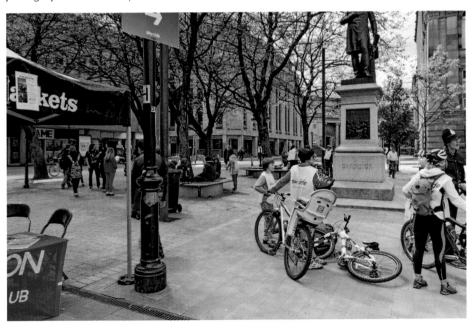

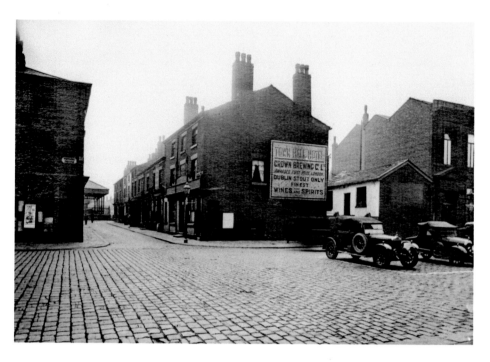

Old Hall Street South

The Town Hall Hotel stood on Old Hall Street South, almost on the alignment of Coronation Street, seen in the modern photograph. The hotel was at one time the venue for the National Independent Order of Oddfellows, Bolton District ('The Conquering Hero Lodge'). The modern photographer's grandfather told him that the hotel was obliged to offer dignitaries visiting the town hall a very much reduced rate in return for having a large advert facing the town hall. The hotel closed in 1933, although it was not demolished until 1947, after which the site enjoyed a period as a grassed seating area. (*Old photograph: Bolton Archives, modern photograph: Alan Bromiley*)

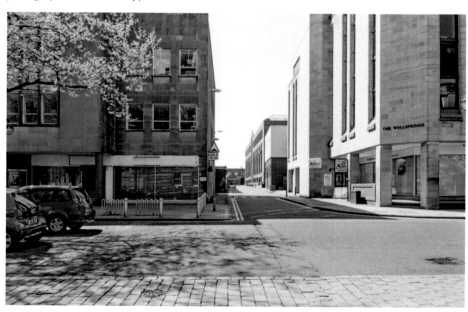

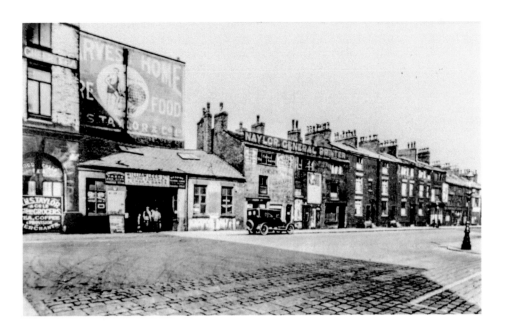

Behind the Town Hall

William Lees of Radcliffe took over the Central Garage (seen on the left in the old photograph) in 1920. Lees advertised that he had 'a new fleet of char-a-bancs, taxis and touring cars ... most up to date models in the North of England'. The charabancs were of the 'modern torpedo body design' by Leyland motors. Also visible in the photograph is an advert for daily journeys to Blackpool at 9 a.m. The buildings in the old photograph were cleared away in 1926 to allow the extension of the town hall, and the new Crescent was completed between 1934 and 1939. The name Le Mans Crescent was adopted in March 1974 to mark the town twinning arrangement with that town in France. (*Old photograph: Halliwell Local History Society, modern photograph: Neil Pilkington*)

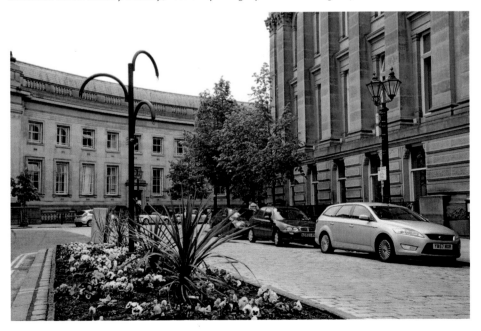

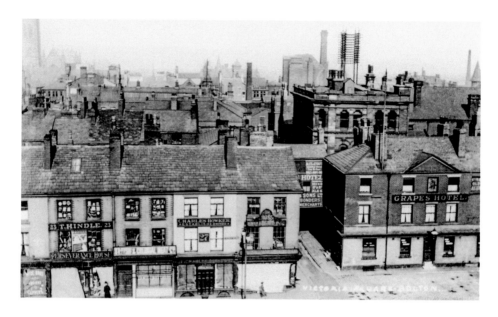

View Across to Exchange Street

Taken from the town hall roof in around 1902, the older photograph shows the Grapes Hotel to the right, and the frontage that became the Arndale Centre in the 1970s to the left. The Grapes was constructed around 1846 and demolished in 1960. Charles Bowker, at No. 27, died in 1902. The sign says 'Established 1829', which was the date of Charles's birth. His father, Abraham, was an overseer in a cotton mill, so was Charles referring to his own 'establishment'? British and Colonial Meat was a trading name for James Nelson & Son, who introduced the first frozen meat imports from South America and New Zealand. Their refrigerated steamers docked at Liverpool once every three weeks. It was reported at the time that the Bolton 'mill-folk will not eat fat meat' and so would only buy the lean mutton from the River Plate. (*Old photograph: Bolton Archives, modern photograph: Tony Watts*)

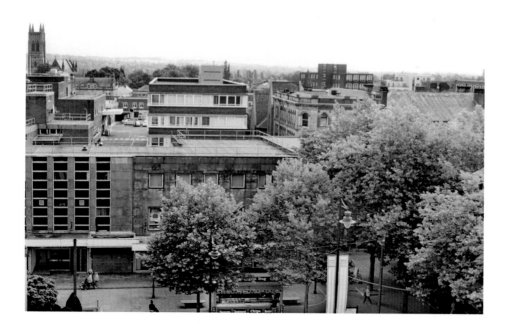

Bolton Town Centre

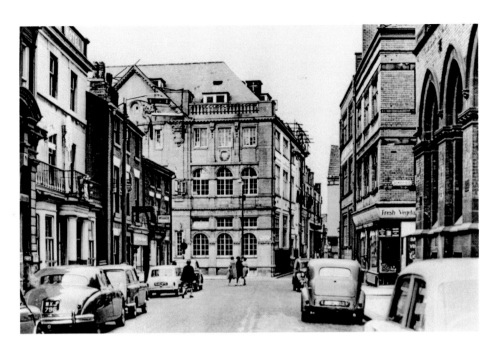

Hotel Street

In 1961, the building at the end of the street was occupied by the *Bolton Evening News*. Its terracotta frontage was typical of many buildings in the area, exploiting otherwise waste clay from local coal mines. On the left the Victoria Hotel is visible with its royal coat of arms over the doorway – believed to be the only Bolton hotel to have enjoyed royal patronage since Prince Arthur was billeted there in 1876, when he was with the 7th Hussars. The hotel closed in 1961 to make way for Marks & Spencer. On the extreme right part of the Bolton Gas Company is visible, where the first telephone experiments in the town were made in January 1878. (*Old photograph: Bolton Archives, modern photograph: Phil Durkin*)

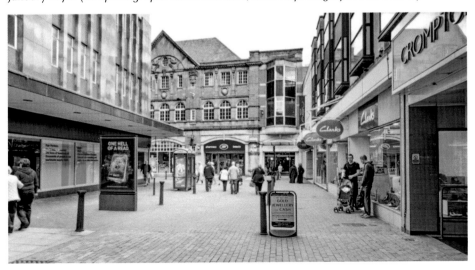

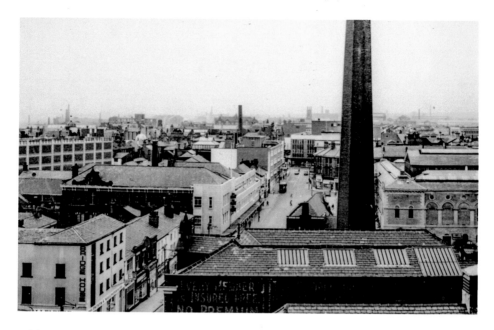

Bridge Street

Taken from the top floor of what used to be the Co-operative linen store, the photographs illustrate some of the detailed, yet significant changes in Bolton town centre since the early 1970s. In the middle distance, to the left of Bridge Street, the Co-operative store has now been demolished and the site redeveloped. The flax mill chimney has vanished and the site used for the development of the Market Place. The area that now contains the Market Place was first proposed for redevelopment as early as 1963, but refused planning permission for being premature. By 1979, interest had revived and Grosvenor Developments eventually completed the scheme in 1989. (*Old photograph: Halliwell Local History Society, modern photograph: Ray Jefferson*)

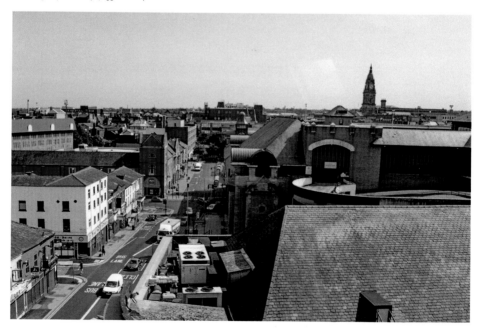

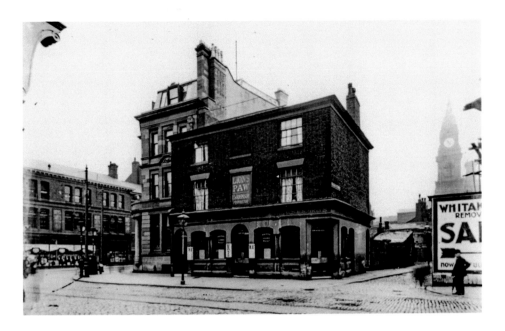

Deansgate

Parr's Bank is on the left and the Lion's Paw public house is to its right. The publican, a Mr Johnson, was advertising Walker's Kilmarnock Whisky and Hennessy's Fine Old Brandies. To the left, the shops on Oxford Street sold men's suits from 30s (£1.50), and boy's suits from 4/6d (22½p). The date must be before 1907 since the site of Whitaker's Tudor-style building, which was formally opened in November of that year, can be seen to the right. In addition, the Lion's Paw became the Silver Vat after rebuilding in 1907, and eventually closed in 1927. The modern photograph shows how the earlier bank building was duplicated mirror-wise. (*Old photograph: Alan Martland collection, modern photograph: Adrian Drummond-Hill*)

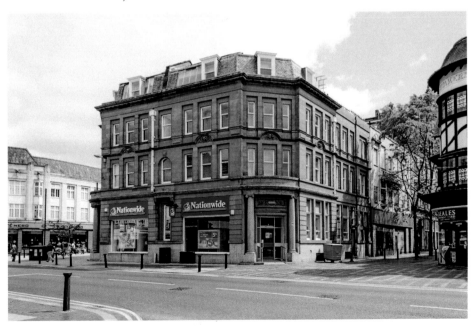

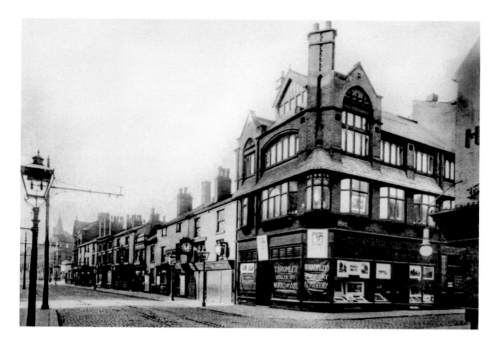

Bradshawgate

Much of the property in the old photograph was demolished after 1904, following the Bolton Improvement Act of 1901. The art shop, on the corner of Fold Street, was owned by T. Bromley, a name still associated with art supplies in Bolton today. Next door, we can see Preston's jewellers – again, a precursor to the modern business on Deansgate. In the distance we can see the terracotta Prudential building, which also appears in the modern image at the corner of Nelson Square. Redevelopment came to the area again in the 1970s with the Arndale development (now called Crompton Place) taking over a major part of the street frontage. (*Old photograph: Halliwell Local History Society, modern photograph: Alan Bromiley*)

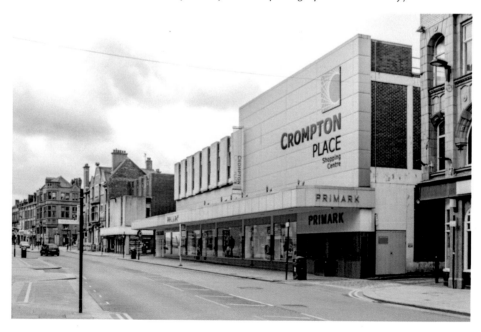

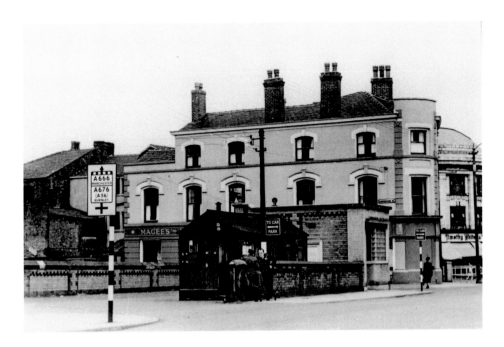

Great Moor Street

The Wheatsheaf Hotel, beyond Coronation Street, seen above, was originally built in 1835, and demolished to be replaced by a modern building in 1962. The replacement pub changed its name to Serendipity's in 1986, but subsequently closed to be converted into a Home Bargains store. The area behind the road sign, where the bus crew is standing, used to be the terminus and shelter for the tram service to Deane until December 1946. In 1958, this area was used to build a block of five shops to provide replacements for others demolished on the west side of Newport Street, as part of the redevelopment there. (*Old photograph: Bolton Archives, modern photograph: Phil Durkin*)

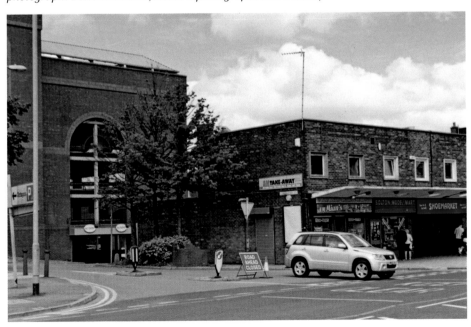

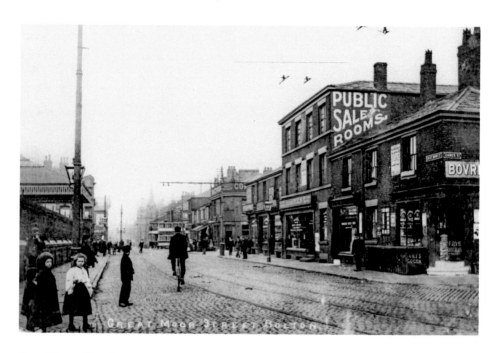

Great Moor Street

Behind the children in the old photograph we can see the roof of the Wheatsheaf Market, which had opened as a wholesale market in 1871. The tram in the background is crossing Great Moor Street along Newport Street, and dates this photograph after 1901. This junction was the first in Bolton to be equipped with traffic lights, which occurred in May 1929. The shop to the right, on the corner of Dawes Street, was selling both Cadbury's and Fry's chocolate, while next door you could buy Horrock's noted tripe as well as cow heels. (*Old photograph: John Turner collection, modern photograph: Ray Jefferson*)

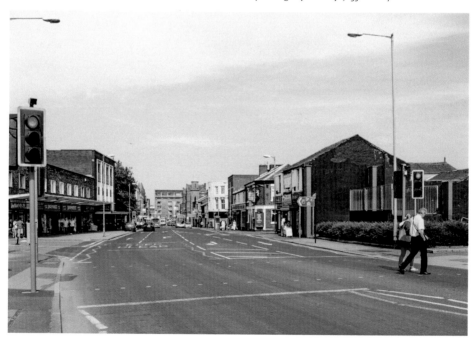

Farnworth Town Centre

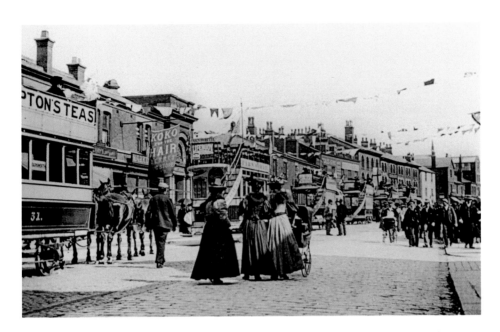

Market Street

A long queue or procession of horse trams and crowds looking like they are enjoying themselves, together with the bunting, suggests a day of celebration – probably Queen Victoria's Diamond Jubilee in June 1897. The large flag at the left advertises 'Koko for the Hair' – a product that first became available in 1888 and contained 94 per cent water, 3 per cent alcohol, and 2 per cent glycerine, with traces of borax and formaldehyde. It was alleged to prevent hair falling out and turning prematurely grey. It fell out of use during the First World War. The modern photograph shows that the general aspect of the scene has not changed much in 116 years. (*Old photograph: Bolton Archives, modern photograph: Dave Ligett*)

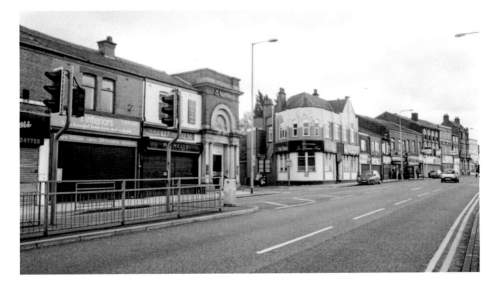

Westhoughton Town Centre

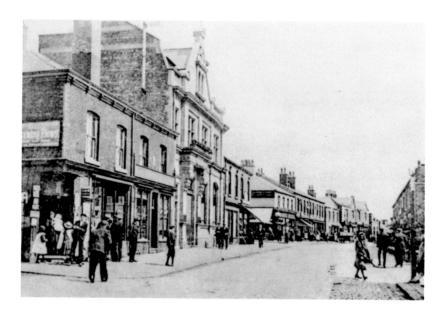

Market Street

Westhoughton Town Hall was designed by the local firm Bradshaw Gass & Hope, and built in 1903 to replace earlier inadequate accommodation elsewhere in Market Street. In the older picture we can just see the town hall under construction in the distance, which helps date the photograph. In the modern photograph, some things have returned to an earlier feel – the street is quieter once again thanks to the Cricketer's Way bypass, the road surface is partly surfaced with setts, and the shop on the corner continues to sell the local paper. (*Old photograph: Bolton Archives, modern photograph: Don Isherwood*)

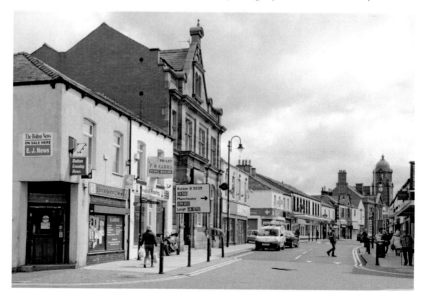

All Change

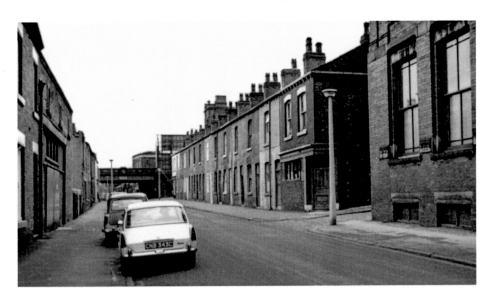

Bark Street

The bridge in the distance carries Marsden Road over Bark Street. Marsden Road is a high-level road that replaced the former Chorley Street/White Lion Brow access to the town centre from the north-west in 1877. The only other structure still existing from January 1968, when the old image was taken, is Claremont church, seen on the extreme right. Over the years, the areas around this part of Bark Street have been cleared of industrial uses and housing, and given over to surface car parking to serve the town centre. Such sites are 'soft' areas, potentially available for future development. (*Old photograph: Geoffrey Whitehead, modern photograph: Alan Bromiley*)

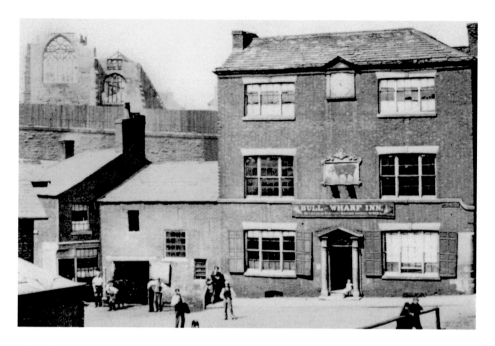

Church Wharf, Bolton

The Bull & Wharf Hotel was built to serve the one-time busy terminus of the Manchester, Bolton & Bury Canal. The canal declined and the pub's trade changed. The hotel eventually closed in 1964, demolished to make way for St Peter's Way in 1966. The old photograph can be accurately dated to 1866, since we can see the demolition of the old parish church in the background (a very early photograph). The grandmother of the modern photographer's wife, Sarah Ann Measures, was a barmaid at the Bull & Wharf and she met her husband-to-be there, a greengrocer named John Ashworth. They were married in the parish church. (*Old photograph: Halliwell Local History Society, modern photograph: Alan Bromiley*)

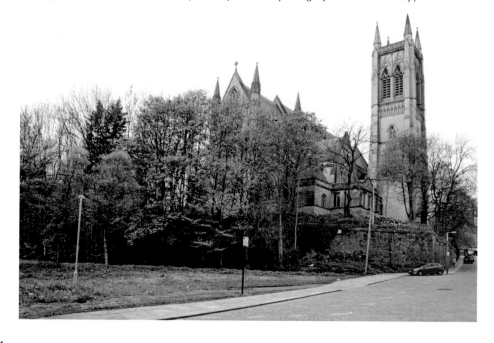

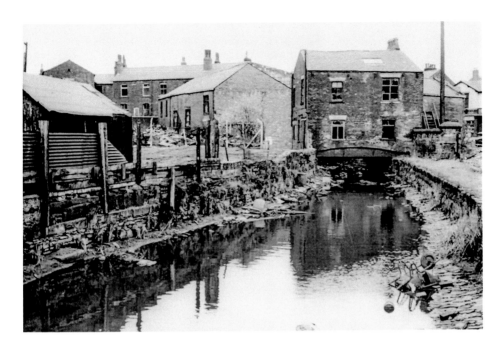

The River Croal at Church Wharf

This length of the Croal was eventually culverted to make way for St Peter's Way. The old photograph was probably taken in the 1960s and, to the left, shows the knacker's yard, officially known as Thomas Brown's Horse Slaughterhouse, which dispatched both horses and donkeys. Other buildings nearby included a storehouse for White's Mineral Waters. Today, the whole area has been used for the route of St Peter's Way, and is inaccessible for an equivalent photograph. The only reminder of the opening to the wharf building is the entrance to the modern underpass. (*Old photograph: Tony Watts collection, modern photograph: Alan Bromiley*)

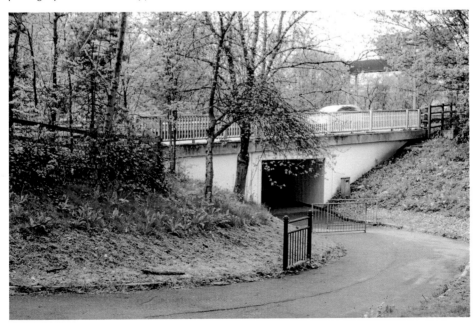

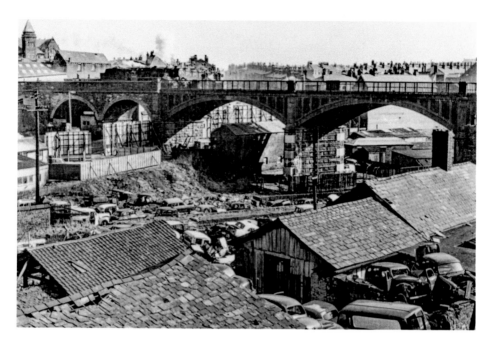

Church Wharf from Church Bank, Bolton

A scene of dereliction and scrap cars greets the Stanier 'Black 5' locomotive moving across the viaduct towards Trinity Street station. The date must be the early 1960s, judging from the types of scrap, and shows the kind of uses that often migrate towards neglected backwaters. The dereliction all along this part of the Croal valley gave the opportunity to construct St Peter's Way with minimum disruption slightly later, and today the scene is transformed. As with many other modern views, at the back of the parish church the scene is obscured by foliage, and so a lower viewpoint was adopted to get a sense of the modern aspect. (*Old photograph: Bolton Archives, modern photograph: Alan Bromiley*)

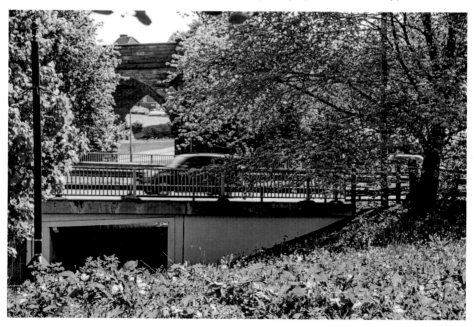

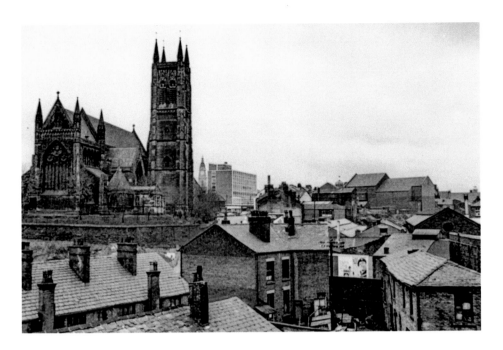

Looking Across Church Wharf, Bolton

In January 1968, many of the buildings around Church Wharf were still standing awaiting their fate pending the construction of St Peter's Way. The culverting of the River Croal was being undertaken, and demolition of this whole area would shortly follow. It is still possible to see this view today if you visit the Audi showroom on Bury New Road, although things have got a lot greener. The parish church is prominent of course, and we can see the town hall and Newspaper House on Churchgate in both images. (*Old photograph: Geoffrey A. Whitehead, modern photograph: Alan Bromiley*)

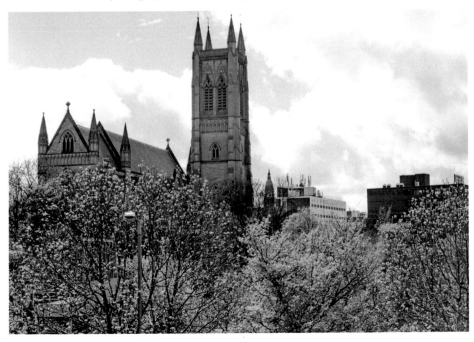

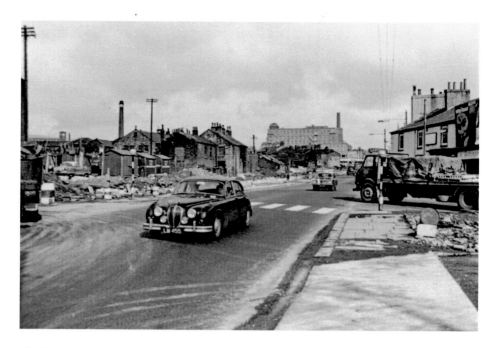

Blackburn Road, Bolton

The Mark 1 Jaguar cruises south into Bolton along Blackburn Road at its junction with Kay Street. The lorry is emerging from what is today the northernmost extent of St Peter's Way. All the buildings to the left and right have now disappeared, including the chimney of the Moss Street baths (*centre left*) and Prospect Mill's No. 2 Mill, which is seen behind the learner driver's Vauxhall Viva car. The Prospect Mill site has subsequently been redeveloped for housing, as has the land being cleared to the left, although a screen of trees and shrubs softens the modern scene. (*Old photograph: Geoffrey A. Whitehead, modern photograph: Daniel Kusnyer*)

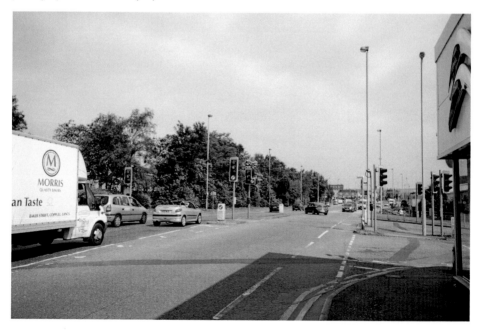

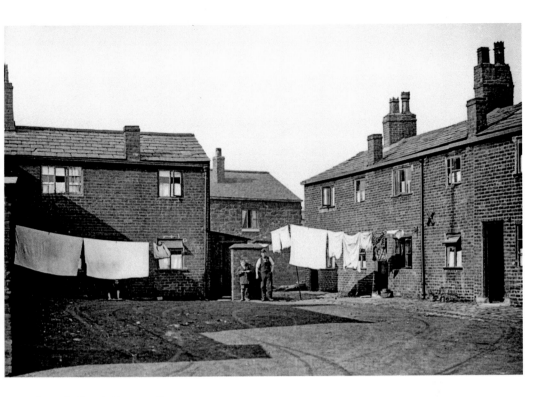

Owen's Court, Farnworth

Owen's Court was located next to Welsby Square, just north of Queen Street in Farnworth. These small courtyards of poor housing were typical of industrial towns all over the north of England in the nineteenth century, and every opportunity was taken to clear them as soon as possible. These particular homes had gone by the time of the 1937 Ordnance Survey map. The area became an open space and has recently been redeveloped as the South Bolton Centre for Bolton Sixth Form College. (*Old photograph: Bolton Archives, modern photograph: Judy Bell*)

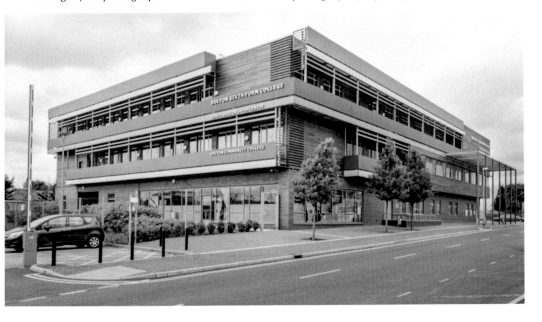

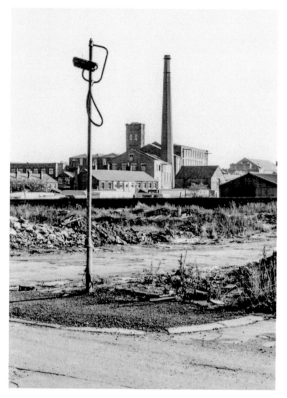

Long Causeway Area, Farnworth
Farnworth has been the subject of major housing clearance and redevelopment in recent decades, and the area to the north of Long Causeway is no exception. In the original photograph, the photographer was standing at the corner of Bridgewater Street and David Street looking south towards Causeway Mill. Just about everything visible in the old picture, probably taken in the 1970s, has now disappeared, to be replaced with comprehensive housing redevelopment. Bridgewater Street and David Street no longer exist, the spot now being located in Dyson Close. (*Old photograph: Bolton Archives, modern photograph: Ray Jefferson*)

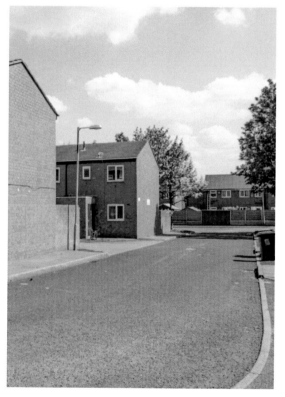

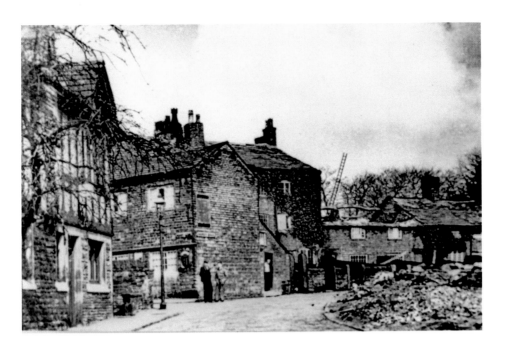

Doffcocker Lane, Bolton

The Jolly Ploughman, on the extreme left, has closed recently, like so many other pubs in the north of England. This was the only surviving building from the older view of the Doffcocker settlement, shown in the old photograph, and the photographer of the old view seems to have stepped in just before demolition took hold. Nowadays, although there are still some roads with setts and some older buildings towards the end of Church Road, this local area has been redeveloped for bungalows and semi-detached homes. (*Old photograph: Halliwell Local History Society, modern photograph: Diane Ronson*)

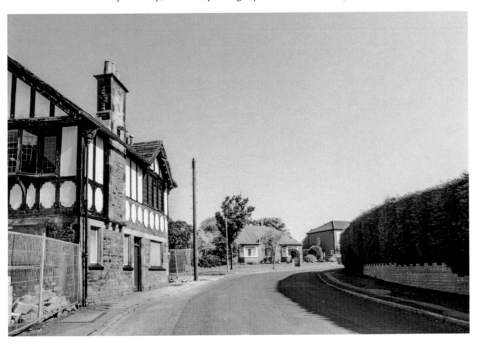

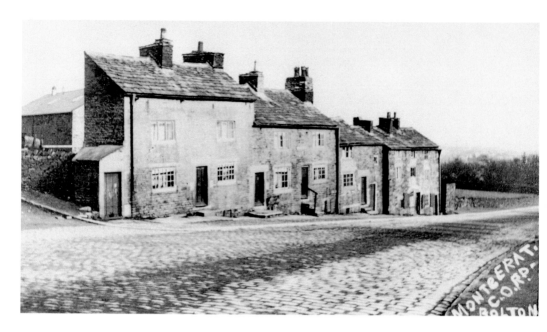

Montserrat, Chorley Old Road

This row of houses appeared on the right-hand side, halfway up the slope from Delph Hill to the Bob's Smithy pub. Behind them can be seen Horrobin Farm, and just down the hill was the Doffcocker colliery, one of the reasons for the existence of this hamlet. As so often, Chorley Old Road at this point consisted of setts. It had been created as a turnpike in 1763. In the modern photograph, Horrobin Farm has given way to the Bolton Old Links Golf Club and the area down the slope has been developed as the Johnson Fold housing estate. (*Old photograph: Halliwell Local History Society, modern photograph: Ray Jefferson*)

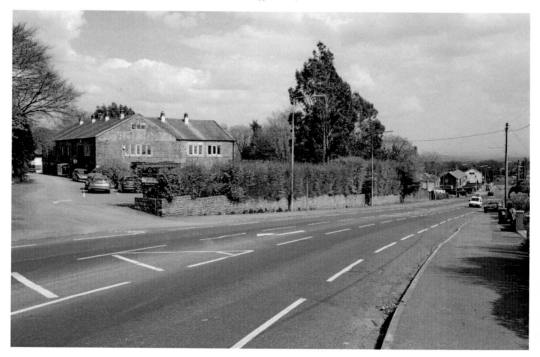

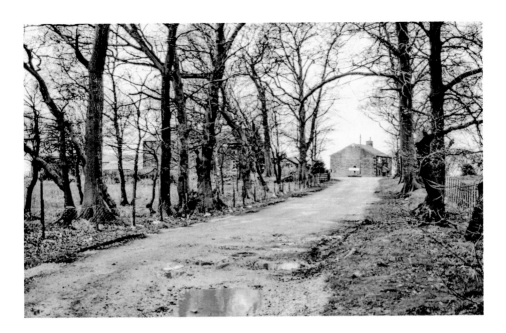

Mansell Way, Horwich

In 1992, a visitor to the Tesco superstore on Mansell Way would have been faced with this view as they turned into the store car park. At the end of the unmade road was Sefton Fold Farm, at one time a council-run nursery and sheltered training establishment. All that changed during the 1990s when the Middlebrook retail and leisure scheme was promoted between Bolton Wanderers Football Club, Orbit Investments and Bolton Council. Today, the trees on the right are still visible, but the route now gives access to one of the most successful retail and leisure parks in the country. (*Old photograph: Ray Jefferson, modern photograph: Ray Jefferson*)

Churches

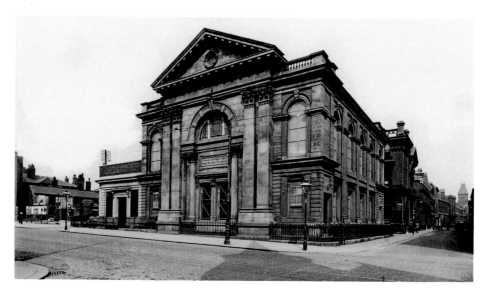

Mawdsley Street Congregational Church, Bolton
In 1870, a new chapel was erected on the Mawdsley Street/Great Moor Street corner to replace one that had been set up there in 1808. In 1926, the imposing frontage to Great Moor Street had to be set back by some 22 feet to allow road widening. The old photograph shows the situation after 1926, since there are five bays facing onto Mawdsley Street compared to the original seven of 1870. In 1962, the church was sold to a London property investment company, and the church disappeared in 1963, after being authorised by parliament (this was required to develop what once had been an old burial ground). A modern retail scheme is the result. (*Old photograph: Bolton Archives, modern photograph: Adrian Drummond-Hill*)

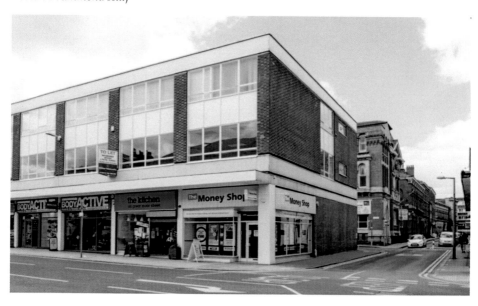

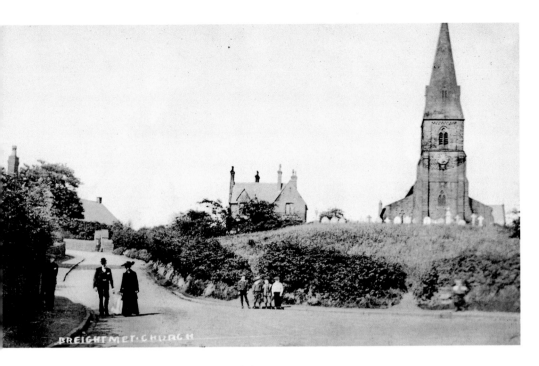

St James's Church, Stephens Street, Breightmet

Canon James Slade was buried in the churchyard at St James's in 1860, the church having been consecrated in 1855. Canon Slade was the founder of the Bolton Church Institute, which was to become Canon Slade School. Once an independent township, Breightmet was incorporated into Bolton in 1898. Once again, the modern view illustrates the growth of trees and greenery over the years. (*Old photograph: John Turner collection, modern photograph: Ray Jefferson*)

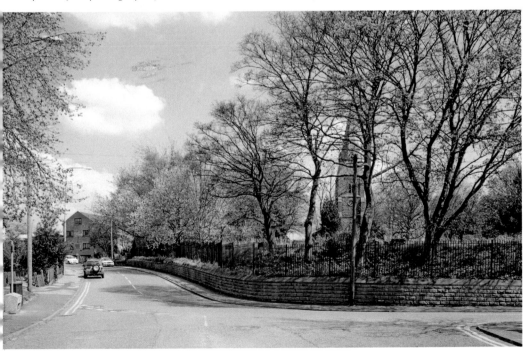

Education

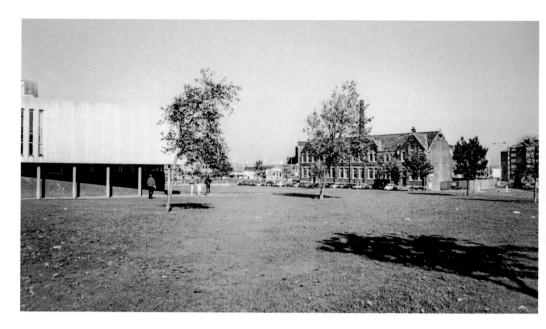

Bolton University, Derby Street, Bolton

The Bolton Institute of Technology building was completed in 1970 to the designs of Geoffrey Brooks, the borough architect. The older picture shows the corner of the Deane Lecture Theatre on the left, and a former Derby Street school building on College Close, which housed the students' union for several years. Hargreaves House, a local authority block of flats can be seen at the extreme right. In the modern photograph, the old school has been removed to be replaced by the Jason Kenny Centre, a £30 million leisure facility. Meanwhile, out of shot to the left, the institute has now become the university, and had a complete makeover as well. Hargreaves House is still visible in the distance. (*Old photograph: Ray Jefferson, modern photograph: Phil Durkin*)

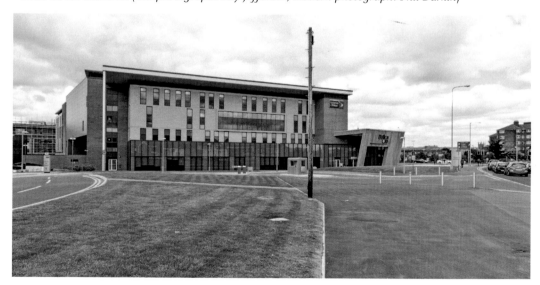

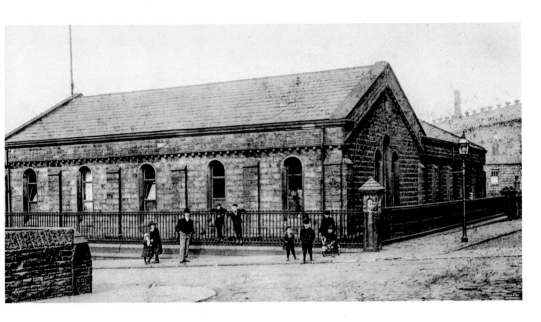

Emmanuel School, Cannon Street, Bolton

The Emmanuel Church National and Sunday School for Boys and Girls was established across the road from the church itself. The boys and girls had segregated playgrounds at that time. In the background on the right we can just see Derby Street Mill, constructed in 1864, and which has been redeveloped for housing in recent years. Meanwhile, the school itself had gone by 1979, and is today the location for new housing. The wall of the churchyard at the corner of Cannon Street and Vicarage Street can be seen to the left in both photographs. (*Old photograph: John Turner collection, modern photograph: Jeff Griffiths*)

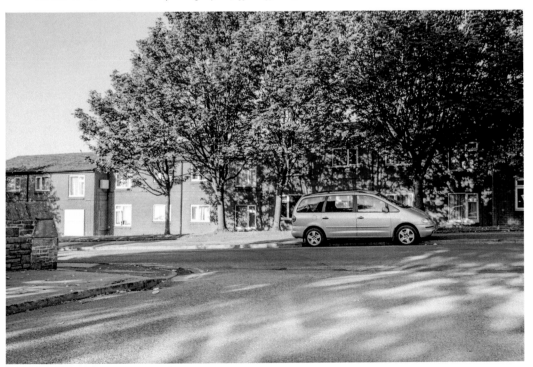

Local Industry

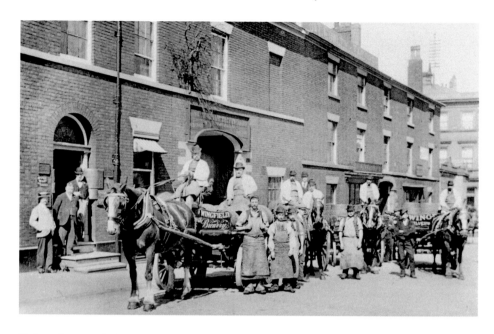

Nelson Square, Bolton

Nelson Square was first laid out in 1823, and for many years was a straightforward, paved area that hosted a local cattle market. Floral beds and shrubs came along in 1893. The horse drays in the picture belong to Wingfield Silverwell Brewery, which had its premises at No. 15 Nelson Square, behind the line-up. The year must be between 1896, when the company was formed, and 1904, when many of the buildings were demolished to improve Bradshawgate. Today, the square has seen many changes, including, along this facade, the expansion of The Pack Horse Hotel, and its recent conversion into student accommodation. (*Old photograph: Alan Martland collection, modern photograph: Ray Jefferson*)

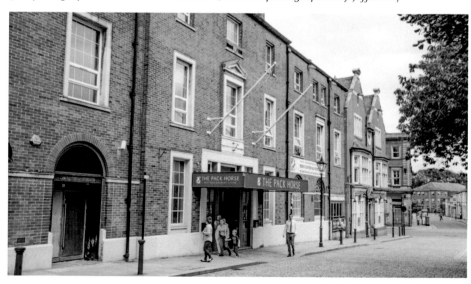

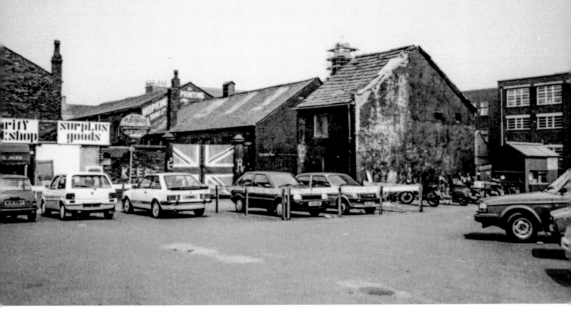

Central Street, Bolton

Taken in May 1987, the old photograph shows the Central Street area. The street started life as Water Street and then became Idle Lane. The name Central Street emerged in 1893, and at that time the area was home to many squalid courts and yards (e.g. Salt Pie Yard and Gibbon's Court). Also hereabouts were Bleasdale's central forge, and the Welsh Tabernacle. The area was subsequently cleared to provide car parking, a situation that persists today in spite of ambitious plans to use the land for a mixed retail and commercial scheme in the early years of the twenty-first century – a scheme prevented by the financial crisis of 2009. (*Old photograph: Ray Jefferson, modern photograph: Phil Durkin*)

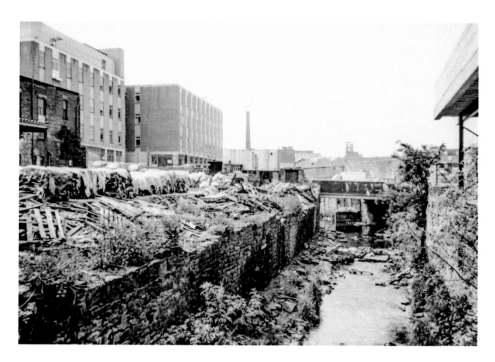

Hide, Skin and Fat Works, Central Bolton

At the bottom of what is now the Central Street car park, next to the River Croal, was the hide, skin and fat works. The Croal had already been so polluted that public pressure to have it paved started in the 1850s. The work on this began in 1864, and continued intermittently until 1911. During this period, in the 1890s, the old Hide, Skin & Fat Co. Ltd moved to this location from Canal Road, near to Church Wharf. This did little to alleviate the difficulty along this stretch of river. The old photograph was taken in 1987, and you can almost smell the picture. Nowadays all is cleaner, and, as the inset picture shows, the original location is now overgrown. (*Old photograph: Ray Jefferson, modern photograph: Bob Holden*)

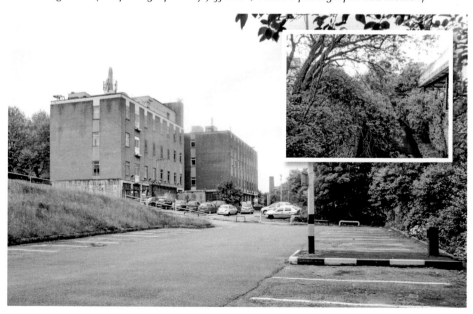

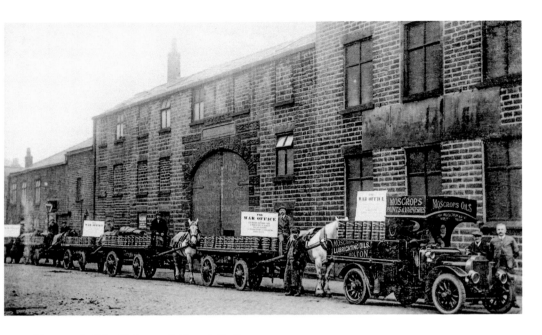

Moscrop's Oils, St George's Street, Bolton

The Moscrop's Lion Motor Oils business was founded in 1838, and the older photograph was taken at an interesting transitional time for transport, with the proud display of motorised traction at the front of the line-up and horse-drawn trailers behind. The notices state that the oil is for the War Office, so it's a fair bet that this was around the time of the First World War – a fact perhaps backed up by the apparent covering of a sign on the wall that might have displayed the company name in more peaceful times. Moscrop's closed in 1978, and the building was to have been used as a local history museum. Then it was a nightclub; but after a fire it has now become apartments. (*Old photograph: Bolton Archives, modern photograph: Walter Morykin*)

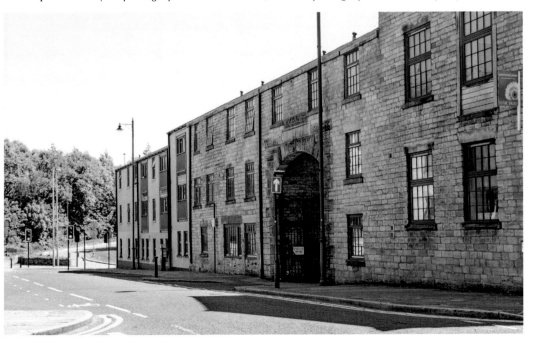

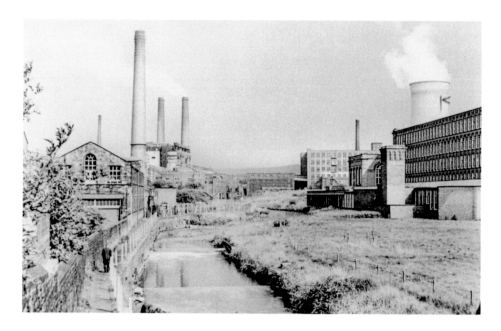

The Tonge Valley

The River Tonge starts where the Astley Brook and Eagley Brook join, near Astley Bridge. The valley has been heavily developed for industry over the years. In the distance to the left can be seen the municipal power station (with its cooling tower on the opposite side of the river), while to the right is Union Mill in the distance, and Dart Mill. After the power station closed, there were years of planning to reclaim the area, which came to fruition thanks to City Challenge funding from Central Government. Today, the area is covered in light industrial, commercial and recreational uses, and a new road spans the river – although not much of this can be seen in the modern photograph. (*Old photograph: Tony Watts collection, modern photograph: Daniel Kusnyer*)

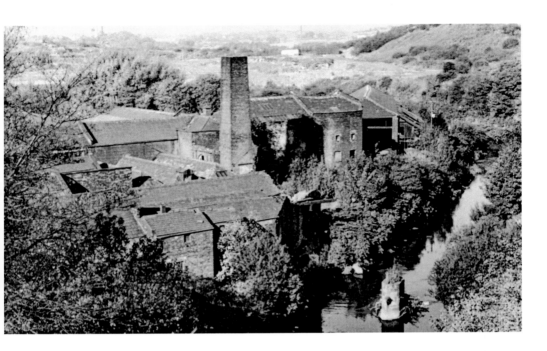

Crompton's Paperworks, Farnworth

Crompton's paper mill was constructed in 1783, probably on the site of an earlier paper mill. It closed in 1883, and remained unused until 1894 when it reopened as J. B. Champion's bleachworks. Paper mills had been located in the area due to the plentiful soft water and easy supply of cotton waste and rags as raw materials. Crompton's paper mill was the first to use drying cylinders to allow a continuous production process for the paper. The older photograph shows the buildings before they were demolished in the 1970s, and the site incorporated into the Moses Gate Country Park. The inset shows the same viewpoint as the old photograph, now obscured by trees. (*Old photograph: Bolton Archives, modern photograph: Mike Hesp*)

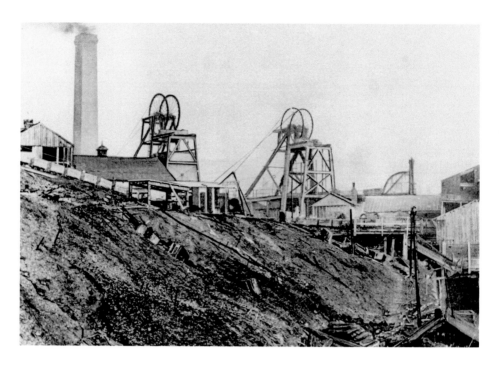

Stott's Pit, James Street, Westhoughton
Stott's Pit was the last of the many coal pits opened in the Westhoughton area after the middle of the nineteenth century. Its closure was forced after water broke through from the abandoned Fourgates Mine in 1935. Efforts were made to save the mine, but to no avail. The coal was far from exhausted, but it still proved uneconomic to reopen the waterlogged mine, even when coal was in great demand immediately after the Second World War. In recent years, the land has been reclaimed from dereliction, and is home to several local companies making a new start. (*Old photograph: Bolton Archives, modern photograph: Ray Jefferson*)

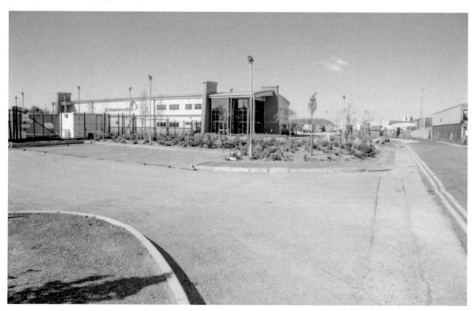

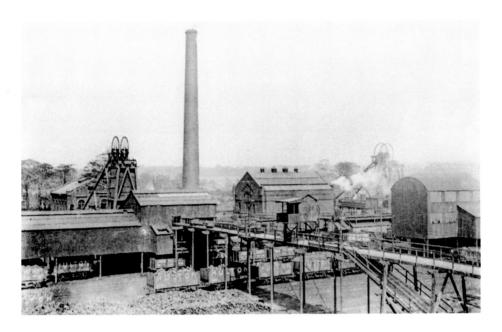

Pretoria Pit, near Hulton Park

Pretoria Pit was the scene of a major mining disaster on 21 December 1910, when 344 men and boys lost their lives in an explosion there. The cause was thought to be gas from a roof fall being ignited by an overhead lamp, which then spread through coal dust. Sixty-one of the victims came from Daubhill and 203 from Westhoughton. In spite of the disaster, production started again within months, and the pit finally closed in April 1934. The old photograph shows the pit just before closure. Nowadays, the site is covered in vegetation, although there are still industrial remains. The inset shows the same viewpoint as the old photograph, but the surviving colliery reservoir makes a better picture. (*Old photograph: Bolton Archives, modern photograph: Ray Jefferson*)

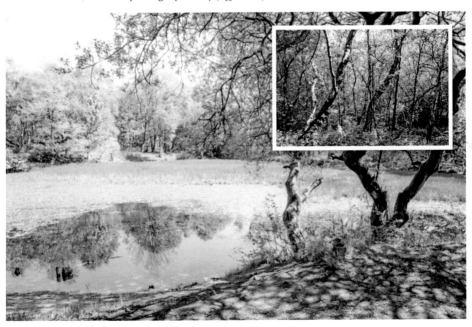

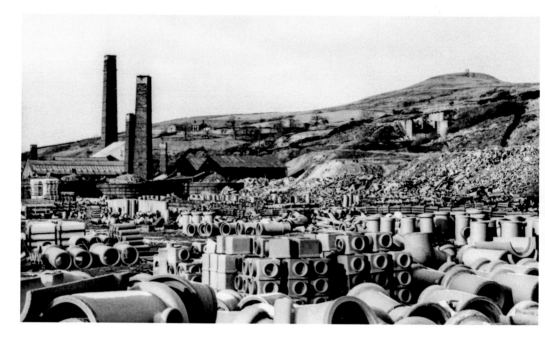

Horwich Pipe Works

Sometimes referred to as 'The Klondyke', the Crankshaw pipeworks were situated on Old Lord's Heights above Horwich. The fireclay to make the pipes used to reach the works from the Montcliffe Colliery (or Pottery Coalpit), higher up the hill, by cable-hauled narrow-gauge railway. The coal mine itself had opened in 1820, and was one of the last privately operated mines in the Bolton area. By 1948, the pipeworks were owned by Associated Clay Industries Ltd. The old photograph was taken in the 1970s, before production ceased in the early 1980s. Today, the whole area has been redeveloped for housing. (*Old photograph: Joan Horner, modern photograph: Ray Jefferson*)

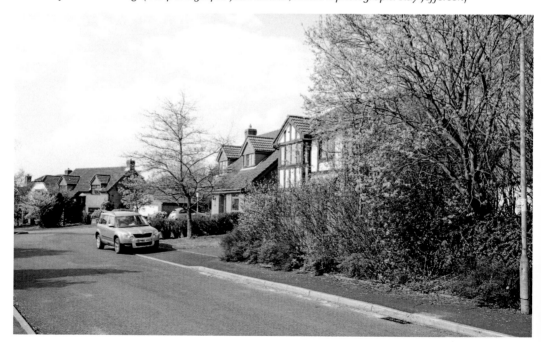

Public Houses

The Grapes Hotel, Water Street, Bolton

Originally owned by a wine merchant, Robert Barlow, these premises on Water Street were used by Bolton's first bank from 1818. It eventually became The Grapes Hotel. The picture on the right shows the publican's name over the door as Robert Tannahill – and the 1911 census shows him in residence. Interestingly, a 1930s photograph of the same pub by Humphrey Spender also shows two men seated in the alcove under the window – they must have moved in the meantime surely? The Grapes closed its doors as a Magee Marshall house in September 1952 and the site today is thickly vegetated, being lost between car parking, industrial activity and St Peter's Way. (*Old photograph: Bolton Archives, modern photograph: Alan Bromiley*)

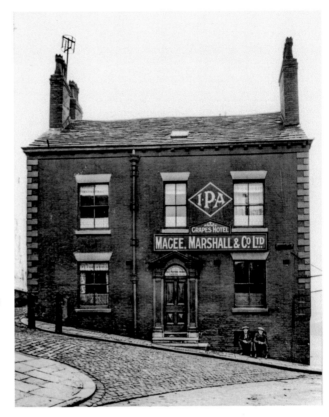

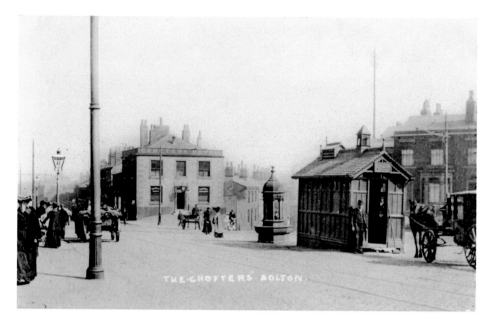

The Crofters, St George's Road, Bolton

The notice on the cab stand describes its location as the 'Jolly Crofters', and is for three cabs. The overhead wires for the trams suggests a date after 1900. Although quite a few people are seen enjoying the sunshine, the traffic is restricted to one cab, three carts and a cyclist – quite a difference to today's busy junction. The Crofters has been rebuilt and seen quite a few changes of ownership in recent years. The modern photograph shows its most recent revival as 'Smudges', although the foliage growing out of the chimney and gutter suggests there is more maintenance to be done. (*Old photograph: Bolton Archives, modern photograph: Walter Morykin*)

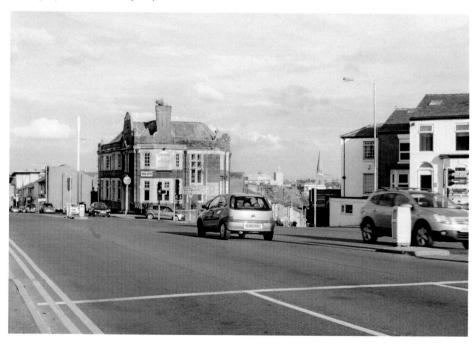

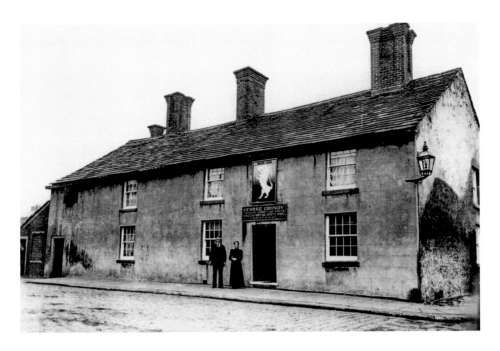

The White Lion, Market Street, Westhoughton

Dating back more than 200 years, the White Lion is an important landmark on the edge of Westhoughton town centre. It was originally used as the town's post office and is on the opposite corner from the mill, which was destroyed during a Luddite riot on 24 April 1812. After breaking into the mill, the rioters smashed the wooden looms and burned the building. Four men were arrested, successfully prosecuted and put to death, although some doubt whether the right men were ever caught. The riot led to a period of decline in Westhoughton, until coal mining became its economic focus later in the century. (*Old photograph: Bolton Archives, modern photograph: Ray Jefferson*)

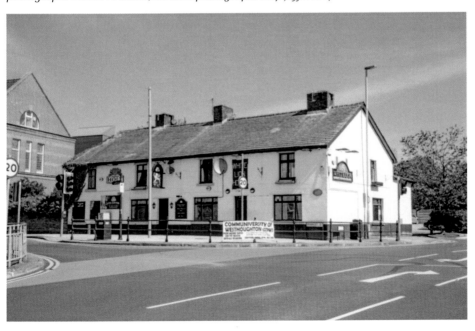

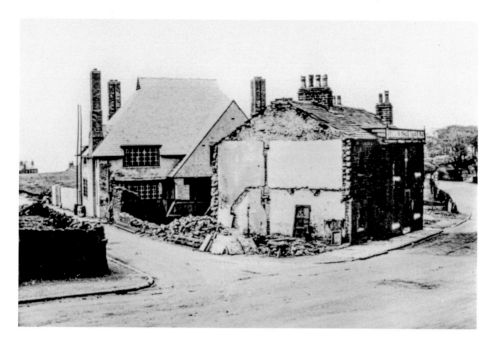

The Jolly Crofters, Chorley Old Road, Horwich

The original pub sited here was the Crofter's Arms in around 1890, situated at the top of the long climb out of Horwich along the original turnpike road to Bolton. Unsurprisingly perhaps, the original cottages used for the public house were known locally as 'Tup Row' (Top Row). The pub's name is associated with open-air bleaching, although Horwich was an early adopter of chlorine bleaching on an industrial scale at the Wallsuches works about half a mile down the hill. In the older photograph, the modern Jolly Crofters is emerging from behind the earlier buildings as they are demolished. (*Old photograph: Bolton Archives, modern photograph: Ray Jefferson*)

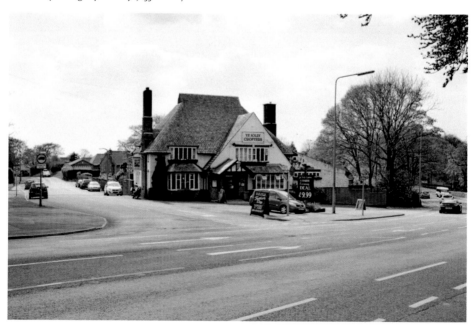

Public Services

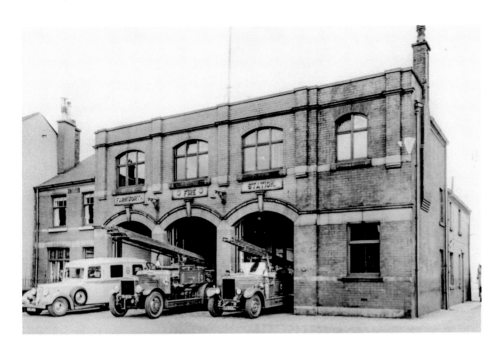

Farnworth Fire Station, Albert Road, Farnworth
The Farnworth fire brigade was first formed in 1864, and the Albert Road station seen in the old photograph opened in July 1914. The pre-Second World War photograph shows an ambulance next to the fire engine 'Edith' in the centre of the group of three vehicles. The current fire station was opened in 1979, and is also situated on Albert Road, a little to the north of the old site. Meanwhile, the older building has been replaced by a Lidl supermarket. (*Old photograph: Bolton Archives, modern photograph: Dave Liggett*)

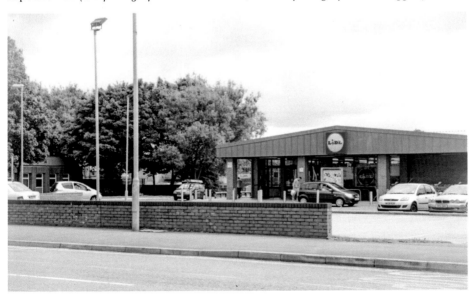

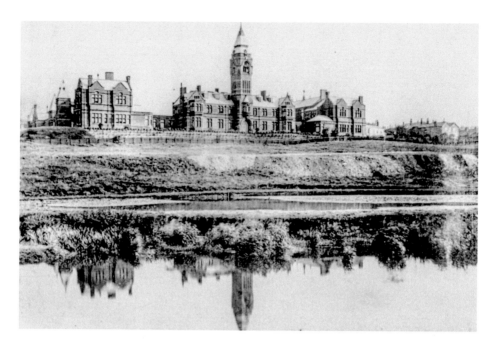

The Bolton Infirmary

In the foreground are the reservoirs for Bridson's Bolton Bleachworks (established in 1832). Beyond lies the old infirmary. This was opened in 1883, allowing the closure of the previous facility in Nelson Square in Bolton's town centre. It became the Royal Infirmary in 1931. This finally closed in late 1996, and the facilities transferred to the Royal Bolton Hospital in Minerva Road, Farnworth. The site has subsequently been reused, amongst other things, for the Bolton Hospice. Today, an approximate equivalent view shows that the water has been incorporated into Queen's Park, and that tree planting screens the older view completely. (*Old photograph: Halliwell Local History Society, modern photograph: Gordon Hartley*)

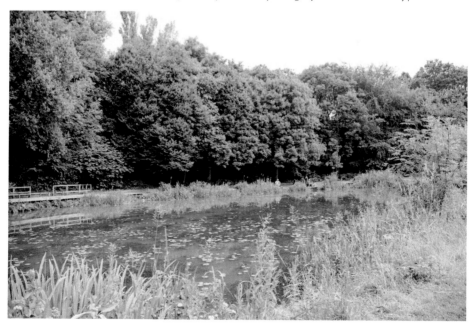

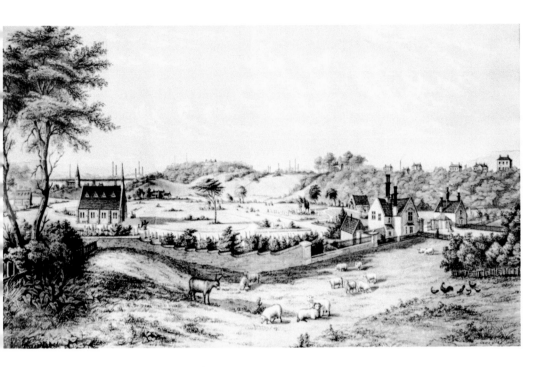

Tonge Cemetery, Tonge Fold, Bolton

The old image is an engraving from the nineteenth century by J. Littler, held in the Bolton Art Gallery collection. It shows Tonge cemetery. Today, the fields around the cemetery have been developed with housing, although the cemetery itself retains much of its character. The inset picture shows the entrance gatehouse visible on the old image. Where the donkey stands in the older picture, today we have modern homes on Tonge Fold Road. (*Old picture: Bolton Art Gallery, modern photograph: Ray Jefferson*)

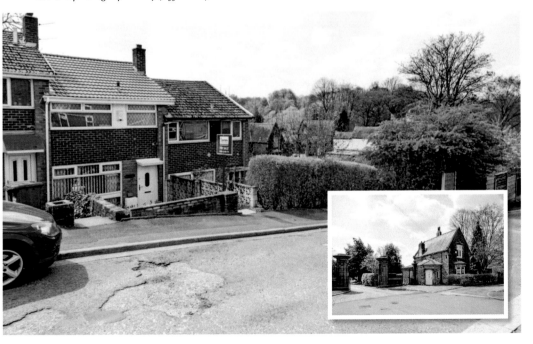

Recreation

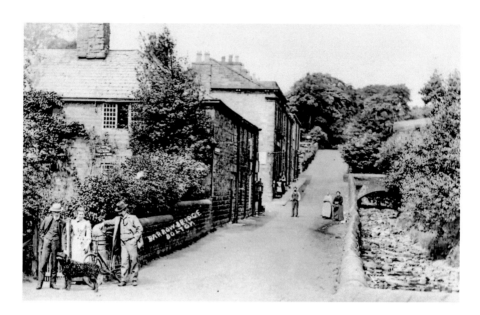

Barrow Bridge, Bolton

Barrow Bridge became a popular destination for day trippers during the twentieth century because of its rural character, boating lake and tea shops. It had its origins, however, as one of Bolton's earliest and, later, largest cotton enterprises, known then as Dean Mills. Robert Gardner purchased the estate for his enterprise in 1831, and by 1846 about 1,000 workers had good houses (some with gardens), a shop, bakery and educational institute. It was a model village visited by Prince Albert in 1851. Nevertheless, the Dean Mills Co. was forced into bankruptcy in 1895, and by 1913 there was almost no trace left of Barrow Bridge Mills. Today, Barrow Bridge is an attractive conservation area. (*Old photograph: Halliwell Local History Society, modern photograph: Richard Towell*)

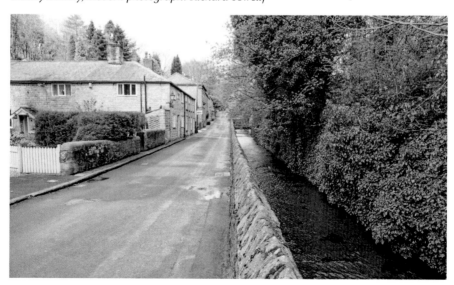

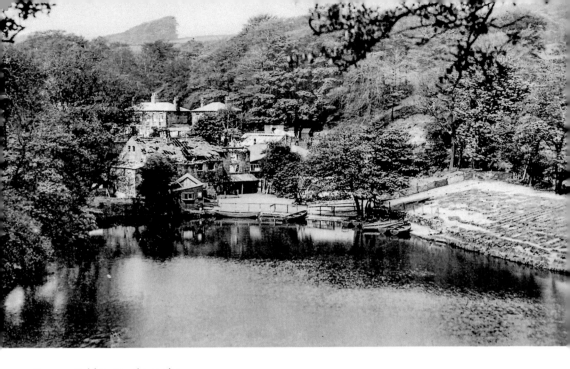

Barrow Bridge Boating Lake

The reservoir for the former Dean Mills complex at Barrow Bridge lost its primary purpose when the mills were demolished by 1913. However, the lake alongside Barrow Bridge Road became a popular day trip destination, especially after the nearby Moss Bank Park was opened in 1922. The older view shows about eight rowing boats drawn up on the lakeside, although the buildings just beyond the lake are derelict. In the distance can be seen the former mill managers' homes on Barrow Bridge Road itself. Today, the lake has been drained and is used as a car parking area. (*Old photograph: Halliwell Local History Society, modern photograph: Richard Towell*)

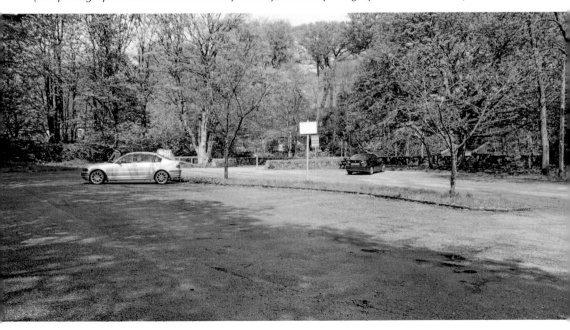

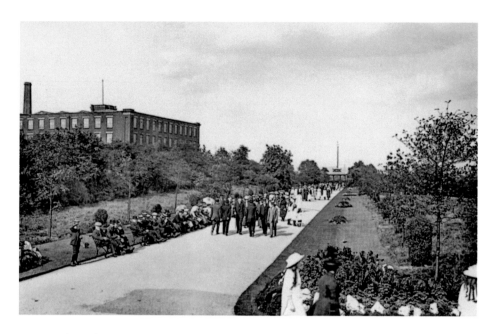

Farnworth Park

William Gladstone opened Farnworth Park in October 1864, when he was Chancellor of the Exchequer. The occasion was a major event with an estimated 100,000 people gathering to witness the huge procession, the speeches and the celebrations. The park was the gift of Thomas Barnes MP to his native town, to mark his son's coming of age. Clearly the park continued to be popular, given the number of people enjoying the afternoon sun in the old photograph. Visible in the background is Albert Mill No. 2, which was eventually demolished to create a modern housing development called Paisley Park. (*Old photograph: Bolton Archives, modern photograph: Liz Jefferson*)

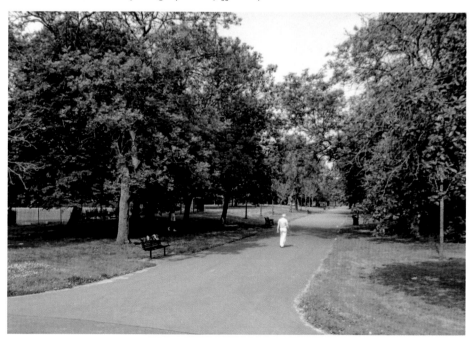

Shops

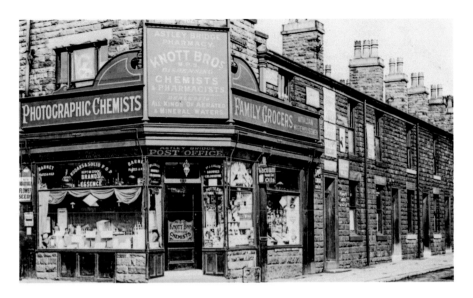

Knott Brothers, Blackburn Road, Astley Bridge
The brothers Percy and Herbert Knott took on the family retail business after their father died in 1888. Herbert managed this shop on the corner of Blackburn Road and Seymour Road, the other outlet being run by Percy at No. 1 Blackburn Road. Percy went on to be an alderman and also mayor of Bolton in 1925. Percy's hobby was photography, an activity well represented in the window of his brother's shop, where Kodak and Solio 'printing out papers' (printing photographs by sunlight) are advertised. Other products include Spratt's Chikko for Chicks and Dr J. Collis Browne's Chlorodyne (originally an alcoholic solution of opium, cannabis and chloroform!). (*Old photograph: Bolton Archives, modern photograph: Mick Stone*)

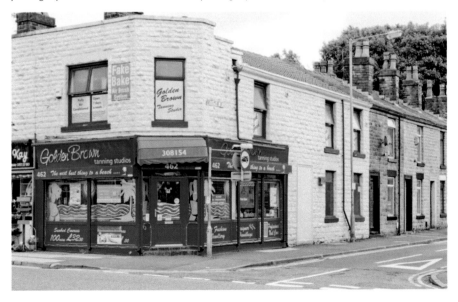

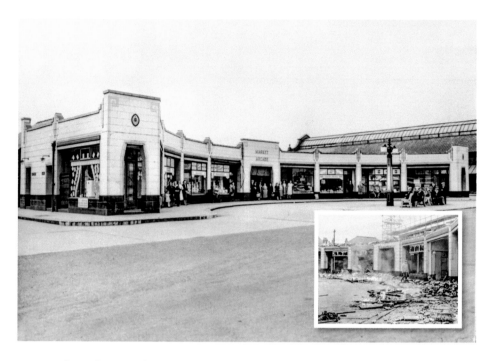

Farnworth Market Arcade

The art-deco style arcade on King Street, Farnworth, was constructed in the 1920s, and incorporated a bus turn-round as an early example of a development taking account of public transport. The shops didn't last long into the 1970s, however; they were demolished *(see inset)*, together with the public swimming baths, the roof of which can be seen in the background of the older photograph. The bus stop and terminus remain. (*Old photographs: Bolton Archives, modern photograph: Ray Jefferson*)

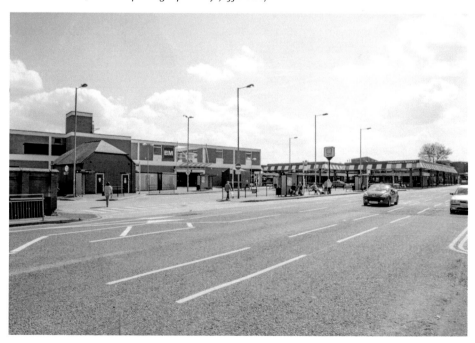

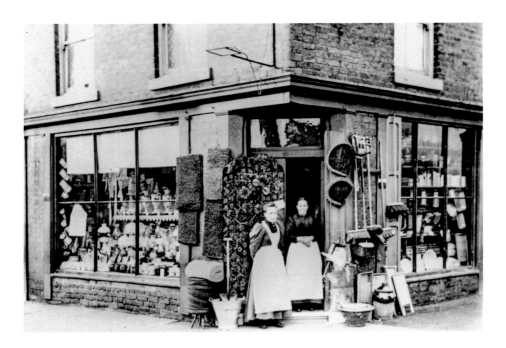

Coops, Market Street, Westhoughton

Showing the two Miss Coops standing outside, this shop is almost certainly the one owned by Timothy Coop, who was twice chairman of Westhoughton District Council (1898/99 and 1903/04). Timothy Coop was a Liberal who described himself as a 'joiner, builder, ironmonger and general dealer'. He was a supporter of the Temperance Movement, and also the corresponding secretary to the Independent Methodist Day School. He had two daughters who survived into adulthood, and it is probably Ann and Matilda at the doorway. Today, an estate agent's stands on the corner. (*Old photograph: Bolton Archives, modern photograph: Ray Jefferson*)

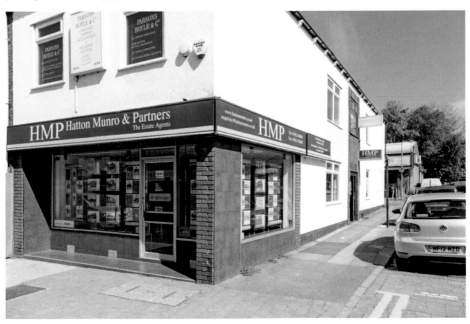

Middlebrook, Horwich

In March 1991, the Middlebrook retail and leisure scheme was still in the future. Bolton Wanderers Football Club approached the council in the early 1990s about the prospects for a major development to incorporate a new 25,000-seat stadium, and Orbit Investments were chosen as a development partner in 1995. Over the next eight years, the scheme produced the stadium, an arena, hotel, restaurants, bowling alley, retail units, housing, office, industrial, warehousing and other uses on an 80-hectare site. The modern view looks over the railway station, developed as part of the scheme, towards the arena and football ground. (*Old photograph: Ray Jefferson, modern photograph: Ray Jefferson*)

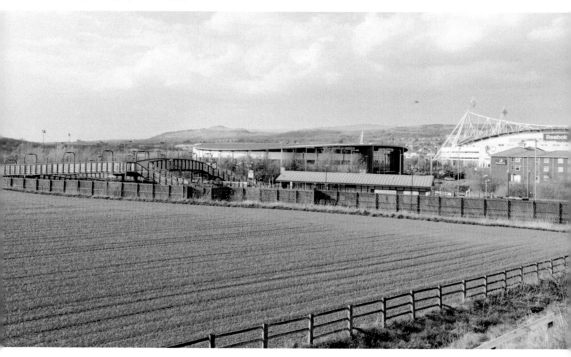

Street Scenes

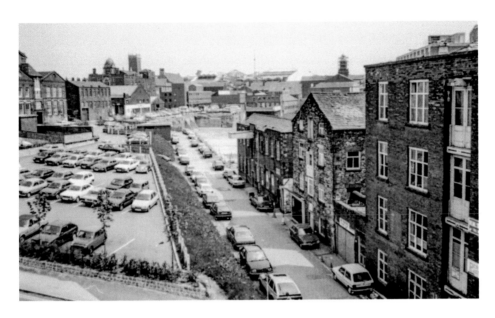

Street Scenes – View From Marsden Road Bridge, Bolton
St Helena Mill, with its gable end facing St Helena Road, was built in the eighteenth century and is claimed to be Bolton's first mill. It was named St Helena after Napoleon was exiled there following the Battle of Waterloo in 1815 – said to be because the mill was on an 'island' at that time, between an artificial watercourse and the River Croal. It is sometimes claimed that Richard Arkwright's water frame was used here, and that Samuel Crompton also worked on his spinning mule in the mill. If so, the mill is indeed an important piece of industrial heritage. Today, the mill has a better setting, and is used by the Probation Service.
(*Old photograph: Ray Jefferson, modern photograph: Phil Durkin*)

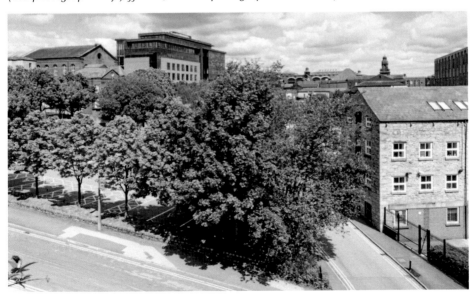

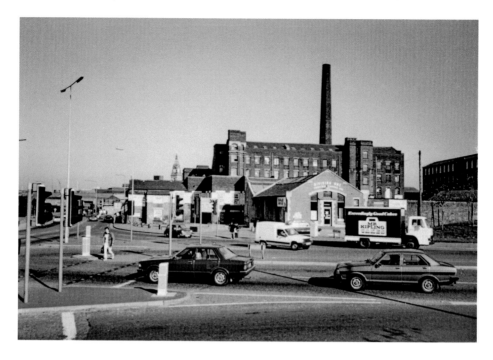

Moor Lane, Bolton

The Flash Street Mills are prominent in the background of the older photograph. In their heyday, the mills were owned by the cotton-spinning and doubling firm of Ormrod, Hardcastle & Co. Ltd, and known as Pin Mill, Royal George Mill and Sovereign Mill. Together with the low-rise buildings in front, the site was cleared to make way for Bolton's first Sainsbury's superstore in the 1990s, although this has subsequently relocated across Trinity Way. Today, the building is used as a casino and bingo hall. (*Old photograph: Ray Jefferson, modern photograph: Phil Durkin*)

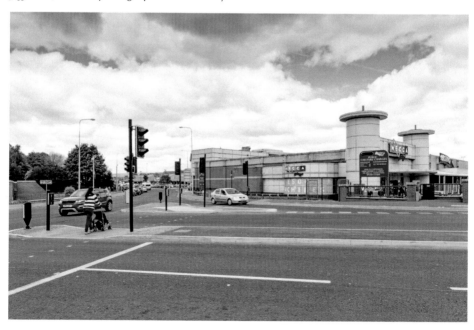

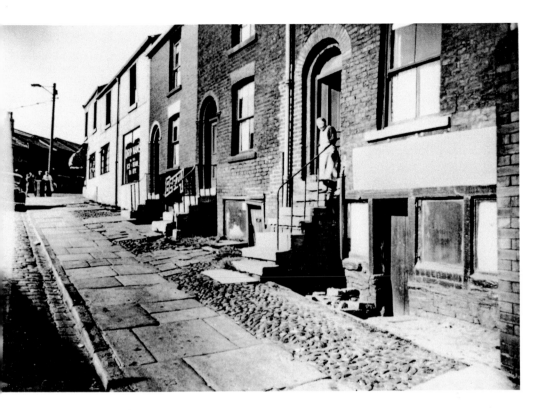

Cannon Street, Bolton

The lady stands at the top of an almost impossible flight of steps leading to her front door soon after the Second World War. Towards the end of the street can be seen Drinnan's ice cream dairy and shop on the corner of Derby Street. This area of unfit housing was eventually cleared away and the site assembled for the Islamic Cultural Centre and Zakaria Mosque in the 1980s. (*Old photograph: Halliwell Local History Society, modern photograph: Jeff Griffiths*)

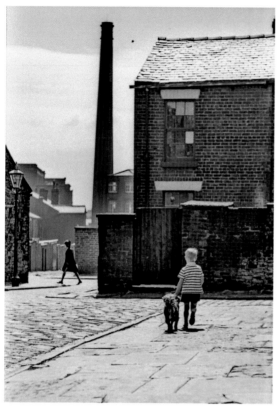

Hugo Street, Bolton

The boy and his dog are walking down Hugo Street towards Turk Street, probably in the 1970s. Setts and flagstones were the traditional materials of Bolton's terraced streets. An original gas lamp standard can be seen at the extreme left. The chimney between Nortex Mill and Haslam No. 2 Mill is a bold feature of the scene. Today, both streets and chimney are gone, although Nortex Mill is still thriving. The area is given over to a modern housing development around Victory Street, named after this part of the town, and a name shared with the nearby Victory Pub and Victory Reform Club. (*Old photograph: Geoff Davies, modern photograph: Ray Jefferson*)

McEvoy Street, Halliwell

Parts of Halliwell have undergone
selective redevelopment over recent
years, and the area around McEvoy Street
is no exception. The older photograph,
probably taken in the 1970s, is looking
east along the street towards the
cooling tower of the power station in
the bottom of the Tonge River valley.
The photographer was standing in
Back Grasmere Street, which still exists,
except that today, instead of the backs
of Victorian terraced housing, more
modern homes have been inserted.
Interestingly, there is still an echo of the
earlier arrangements in the provision of
three bollards and some setts at this spot.
(*Old photograph: Geoff Davies, modern
photograph: Ray Jefferson*)

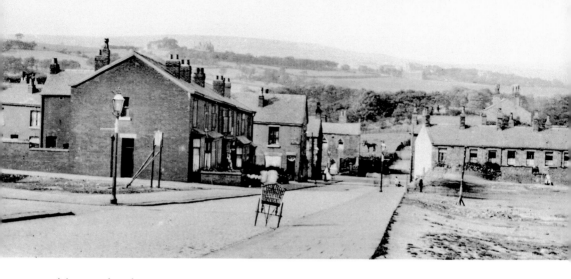

Adrian Road, Bolton

By around 1910, the development of Bolton's built-up area had extended along Halliwell Road as far as the Ainsworth Arms, and housing was being constructed in side streets such as Adrian Road. Vacant sites were still available (possibly the subject of the notice on the site to the left) and what looks like a wicker delivery barrow was standing at the kerb. Today, a petrol filling station and garage takes up much of the vacant plot on the right-hand side of the old photograph. (*Old photograph: Halliwell Local History Society, modern photograph: Diane Ronson*)

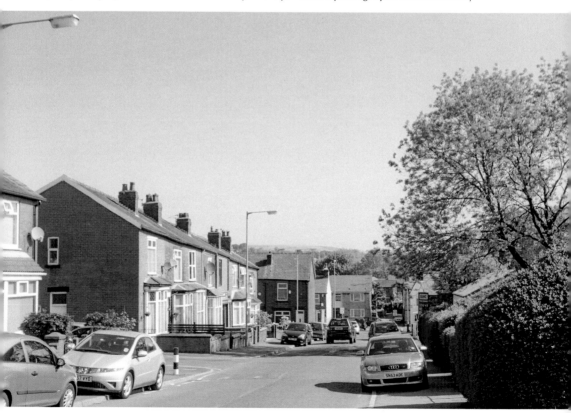

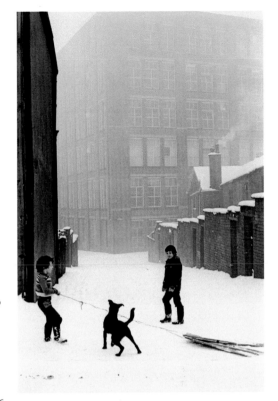

Falcon Mill, Halliwell

The children are playing on a back street to Saturn Street that connects Harvey Street with the corner of Falcon Mill, probably in the 1970s. Falcon Mill was constructed in 1903 on the site of the former Brookfield Mill, and was one of the first mills to have concrete filler joist floors to improve fire resistance. Today, it is listed as a building of architectural or historic interest. Meanwhile, the old terraced streets (on Saturn Street and Delamere Street) have gone and have been replaced with green areas and bungalows. (*Old photograph: Geoff Davies, modern photograph: Diane Ronson*)

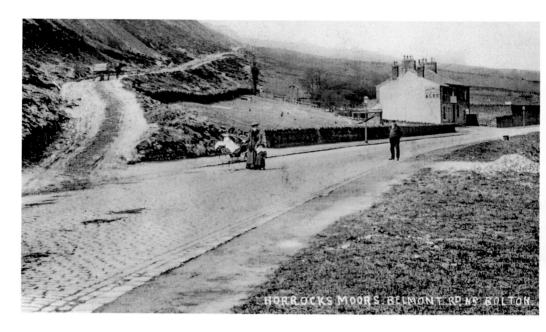

The Wilton Arms, Near Horrocks Fold, Belmont Road, Bolton

A horse and cart begins the stiff climb towards the quarries on Scout Road as a man and a woman pause, seemingly bemused by the photographer. In addition to a large hat, the woman appears to be wearing a fox fur and has two children, one in a pram. In the distance we can see the Wilton Arms, described as a beer house on the 1893 Ordnance Survey map. As with many of the modern photographs in this collection, the most apparent change from earlier times is the amount of tree cover. There are some trees in the pub garden in the old photograph, but today the trees are all along the roadside, up the slope and on the skyline. The Wilton Arms is now, of course, an establishment offering the full range of refreshments and catering. (*Old photograph: John Turner collection, modern photograph: Richard Towell*)

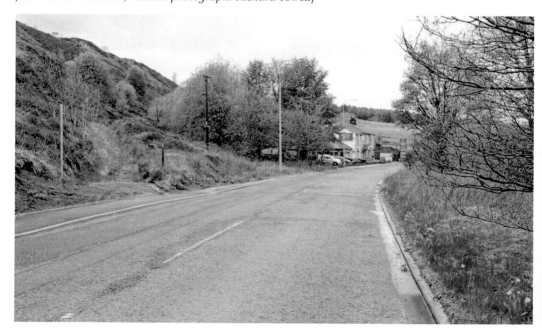

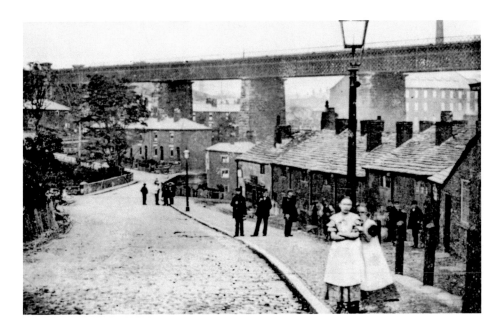

Hag End Brow, Lever Bridge

The railway viaduct in the background was constructed by the Lancashire & Yorkshire Railway in 1848, and was reconstructed in 1881. The Bolton tram route A reached Hag End Brow in 1910, so the older picture must pre-date this. In the background is Darcy Lever, a good example of a water-powered industrial community, which later converted to steam power and was fed by coal from three mines, all within a quarter of a mile. Slightly further afield, the Ladyshore Colliery south of Little Lever supplied the clay that was used to build the first ever terracotta church, St Stephen and All Martyrs, just to the left of the view in the photographs. (*Old photograph: Halliwell Local History Society, modern photograph: Ray Jefferson*)

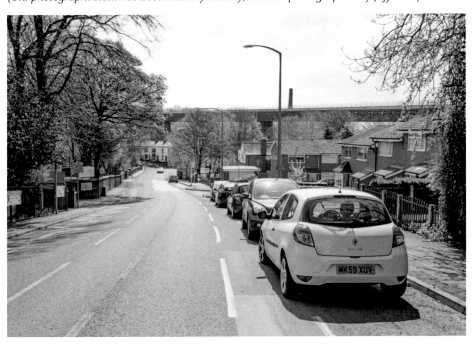

Ormond Street, Darcy Lever

A small row of terrace houses fronts a street made of setts, across from which runs the course of the Manchester, Bury & Bolton Canal. The canal bridge parapet can be made out on the right. The houses must have been found wanting because if you return to the site today, the five cottages have disappeared. The canal itself is, of course, no longer in water at this point. As with so many other comparisons with pictures of the Bolton area of the past, the number of trees and general growth of greenery is very marked. (*Old photograph: Joan Horner, modern photograph: Ray Jefferson*)

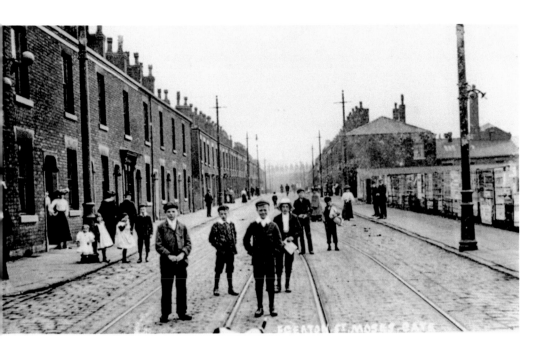

Egerton Street, Moses Gate, Farnworth

The electric trams came to Farnworth at the turn of the twentieth century, and the passing loop for trams seen in the old photograph was alongside the junction of Egerton Street and Francis Street. As so often happened when the photographer set up his tripod, local people came out to look – and didn't have any qualms about standing in front of the camera (notice the dog just visible in the foreground). In practice, the cameraman didn't usually mind, since his objective would be to sell the subsequent postcards to the family and friends of those depicted. Today, there would be few people to emerge since the area is wholly commercial/industrial. (*Old photograph: Bolton Archives, modern photograph: Mike Hesp*)

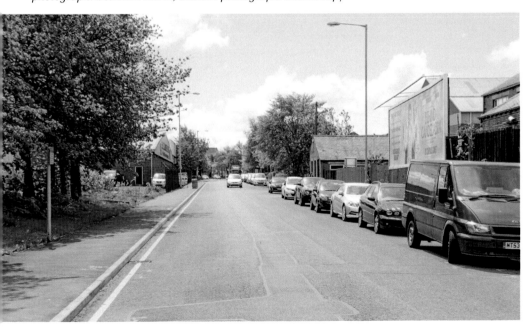

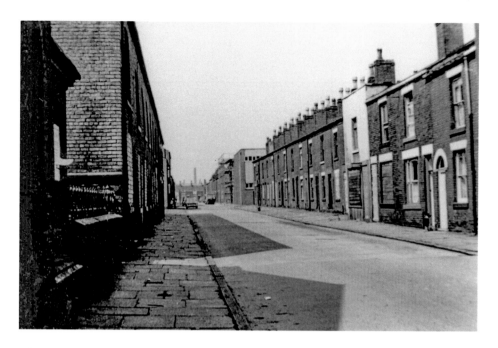

Ellesmere Street, Farnworth

There is little traffic visible in the 1972 scene, but then many of the houses had already been boarded up prior to comprehensive clearance. In the middle distance on the right-hand side of the road, the Farnworth Veterans Club can be seen with its small square windows. As in so many other clearance areas, licensed premises were often left out of a scheme because they were so expensive to acquire by compulsion. Today, the area enjoys new housing and is the car park for the Asda superstore. The Veterans Club is still visible through the trees. (*Old photograph: Bolton Archives, modern photograph: Mike Hesp*)

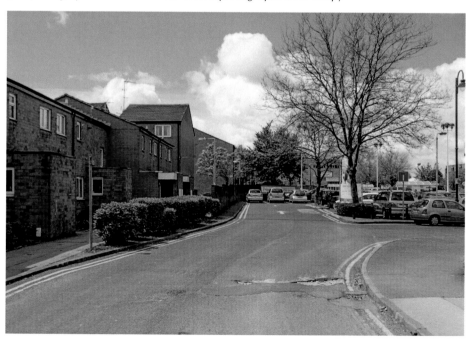

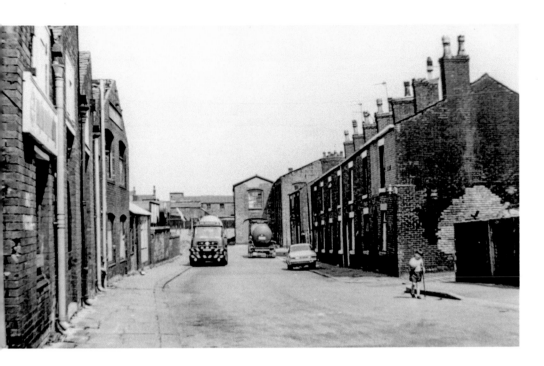

York Street, Farnworth

A boy with a stick and ball plays in the street in this view, probably from the 1970s. Today, most of the buildings have changed and the street has been divided in order to prevent rat running by traffic. The only surviving buildings are the premises behind the tanker lorry in the old photograph, which today act as an outlet for wallpaper, paint and ceramic tiles. This building is located beyond the junction of York Street and Frederick Street. (*Old photograph: Bolton Archives, modern photograph: Mike Hesp*)

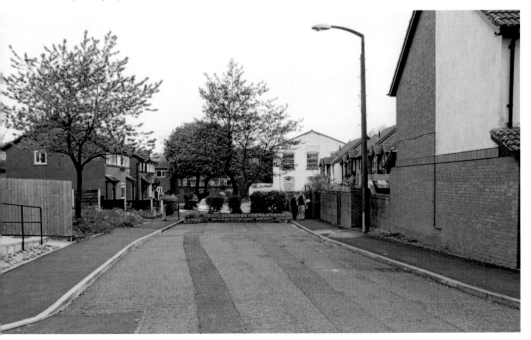

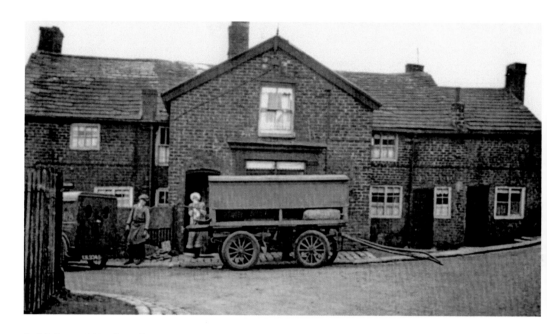

Dobb Brow, Westhoughton

In 1935, Westhoughton Council produced a report on housing conditions, and these properties featured. Whether they were viewed as being in good or bad condition is unclear, although the properties still exist, albeit with modernisation. The Wigan registered van seems to have finished his delivery to a shop, and the unhitched wagon outside has what looks like a sack of potatoes inside and a set of scales on the tailgate. Dobb Brow is a pleasant corner today, still enjoying a discrete separation from Westhoughton alongside Pennington Brook. (*Old photograph: Bolton Archives, modern photograph: Ray Jefferson*)

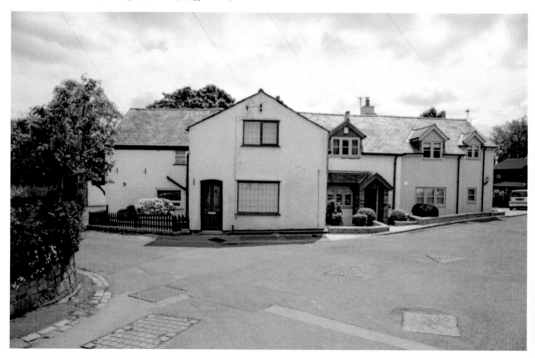

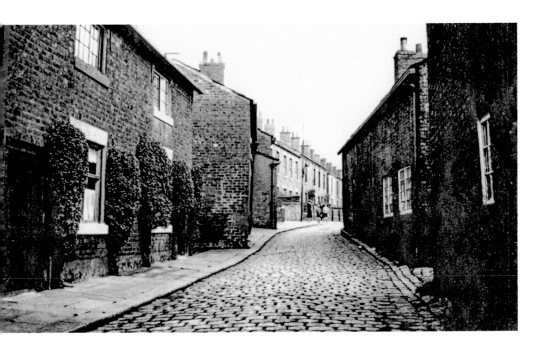

Cemetery Street, Westhoughton

The western end of Cemetery Street also appeared in the 1935 housing report, but this time the older housing has been cleared away, giving more space to the cemetery proper. This little enclave of housing seems to have had its roots in a farm originally, distinct from Westhoughton itself. The cottages on the left show signs of rebuilding and repair, and the climbing shrubs against the wall seem well ordered and under control. These properties had disappeared from the Ordnance Survey map by the mid-1950s. (*Old photograph: Westhoughton Public Library, modern photograph: Ray Jefferson*)

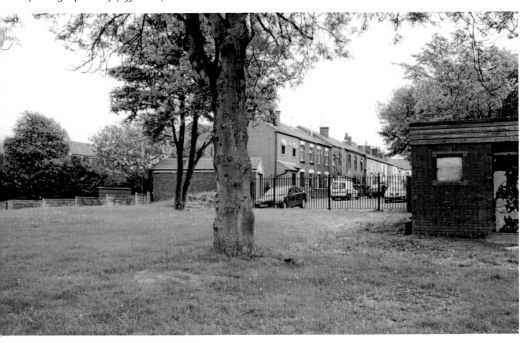

Travelling Around

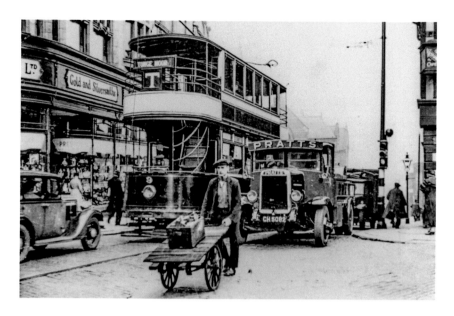

Bank Street/Churchgate Junction, Bolton

Pratt's Anglo-American Oil had a base in Bridgeman Street, Bolton, supplying fuel for motor vehicles. They became better known as Esso in 1935. Their Leyland Lynx tanker lorry is seen following the workman and his handcart, who seems oblivious to whether he may be causing a hold up. Preston's of Bolton, seen on the left, is where a time ball was raised on the roof at 9 a.m. daily and then dropped down at 10 a.m., precisely upon receipt of a time signal from Greenwich. The tram about to launch off down the hill to its terminus at Tonge Moor was one of the first batch that was built for Bolton Corporation in 1900, originally as an open-topped car. (*Old photograph: Tony Watts collection, modern photograph: Bob Holden*)

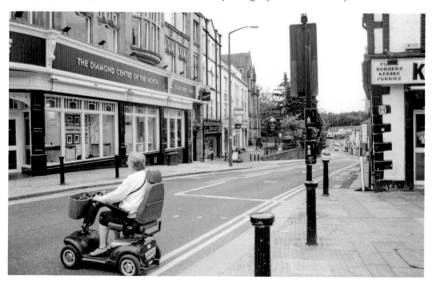

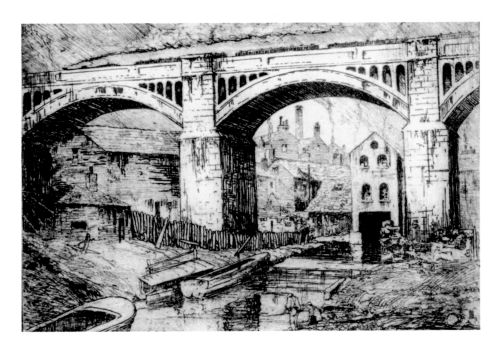

Church Wharf, Bolton

The engraving is one held in the Bolton Art Gallery. It is by Bernard Townend and shows Church Wharf at the terminus of the Manchester, Bolton & Bury Canal in around 1910. The canal had been constructed between 1791 and 1808, and was a busy terminus, sending up to six packet boats each day towards Manchester. Goods carried included coal, cotton, timber, bricks and stone. It is said that the bells of the parish church were rung when barges were ready to depart. The journey time to Manchester was about three hours. The barge trade ceased at about the time the engraving was made. Today, St Peter's Way passes under the surviving railway bridge. (*Engraving: Bernard Townend, modern photograph: Adrian Drummond-Hill*)

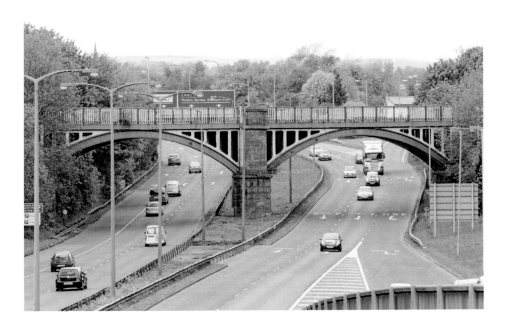

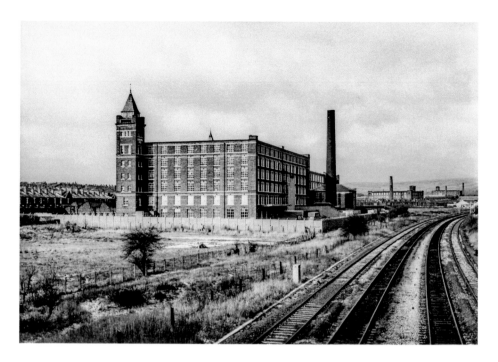

The Main Railway Line in Great Lever, Bolton

The railway between Manchester and Bolton was opened in May 1838, and the original route is the only one that remains open today. In the older view, taken in the 1970s, we see Beehive Mills, off Crescent Road. The site of the former steam locomotive shed beyond the mills has already been demolished. Today, the mill chimney has been truncated, and the vacant sites each side of the mills have been developed for houses and apartments. (*Old photograph: Joan Horner, modern photograph: Ray Jefferson*)

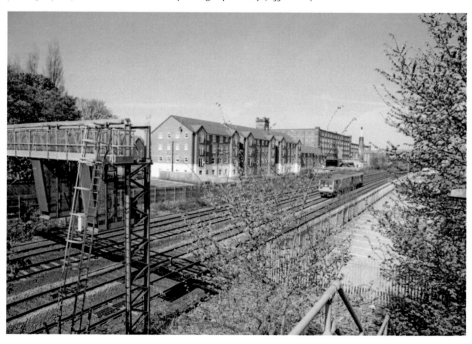

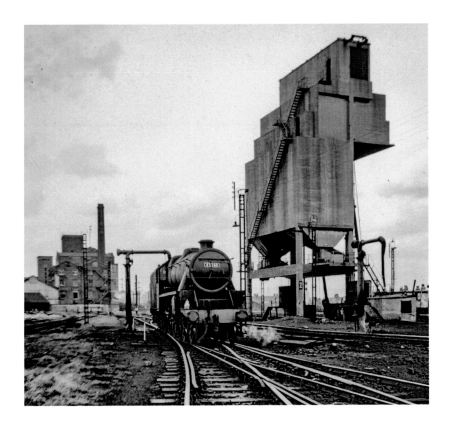

Bolton Railway Engine Shed

Bolton engine shed closed on 29 June 1968, shortly before the withdrawal of the last steam locomotives on the British railway system. In the old photograph, Stanier 'Black 5' locomotive 45260 is seen taking on water in March 1968, with a good view of the coaling tower beyond. Today, the only reminder of the old arrangements is in the street name – 'The Sheddings'. (*Old photograph: John Sloane, modern photograph: Gordon Hartley*)

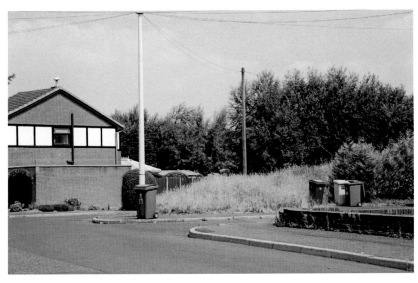

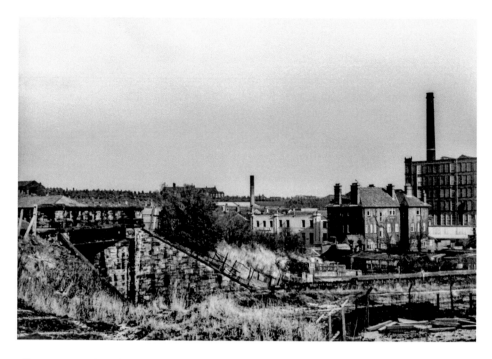

Ellesmere Road Bridge, Daubhill

Probably taken in the 1970s, the earlier photograph shows Ellesmere Road crossing the line of the Bolton to Kenyon Junction railway. This part of the line had been built in the 1880s as a diversionary route to avoid the original Daubhill incline. Regular services were withdrawn in 1954, and all passenger services ceased in 1958. In the background, we can see the bulk of Swan Lane Mills, originally a cotton-spinning mill built in 1906, and now listed as a building of architectural interest. (*Old photograph: Joan Horner, modern photograph: Jeff Griffiths*)

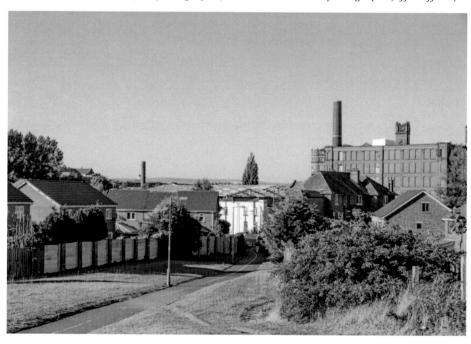

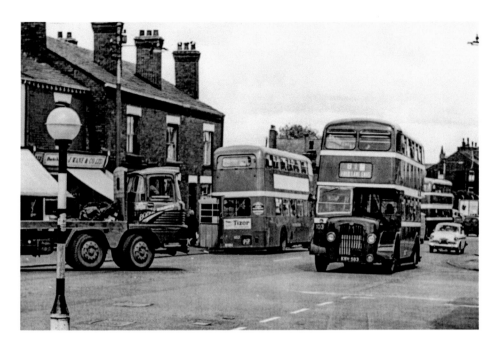

St Helens Road/Deane Church Lane

The bus approaching is Bolton Corporation No. 103, an MCCW-bodied Daimler bus that was new in 1957, and is en route to Four Lane Ends. The original trolleybus service on this route was withdrawn at the end of August 1958. Going the other way is Lancashire United Leyland PD3 No. 653, delivered to them new in September 1958. Emerging from Deane Church Lane, where the lorries used to be maintained, is an eight-wheeled Scammell Routeman Mk II flatbed truck of Bolton Roadways. The absence of traffic in the modern photograph is unusual. (*Old photograph: George Sewell, modern photograph: Jeff Griffiths*)

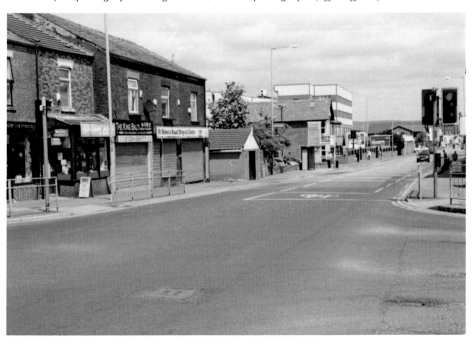

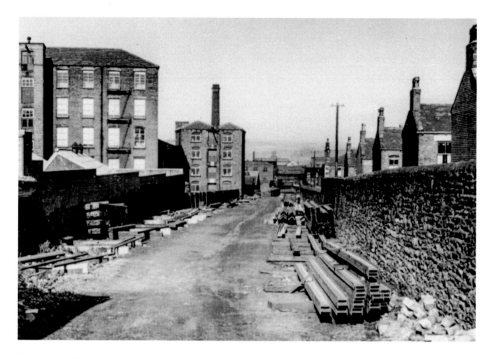

Former Railway at High Street, Bolton
Harold Bowtell was a keen railway historian and took pictures in the Bolton area in 1952. This one shows the steep original course of the Bolton & Leigh railway leading east towards the Bolton Great Moor Street station. Today, the line has been put to other uses, and at the High Street crossing a new house has been constructed, although it is still possible to make out the line of the original wall on the right-hand side. (*Old photograph: Harold D. Bowtell, modern photograph: Paul Longdon*)

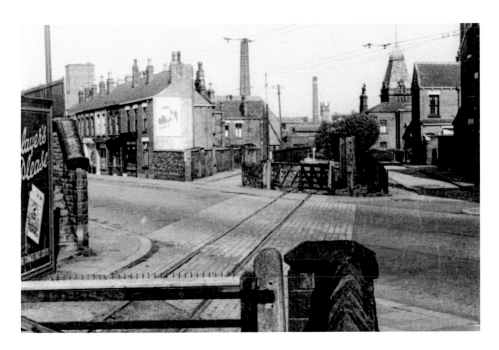

St Helen's Road, Daubhill

Another of Harold Bowtell's images of 1952 vintage looking at the original route of the Bolton & Leigh Railway. This ceased to be a through route for the railway in 1885, and was subsequently relegated to a siding giving access to a coal yard. At this point, the railway crossed St Helens Road on the level, and the wires for the local trolleybus service can be seen overhead. Nowadays, the route of the railway is occupied by a dance studio. The tower on Rumworth Mill can be seen towards the left-hand edge of both photographs. (*Old photograph: Harold D. Bowtell, modern photograph: Paul Longdon*)

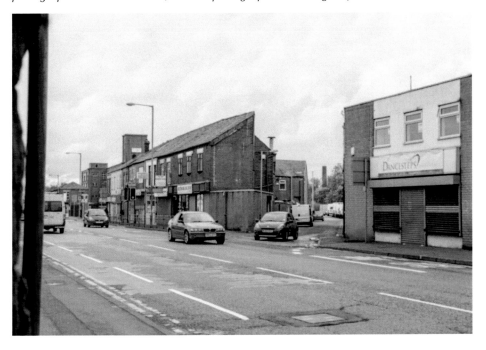

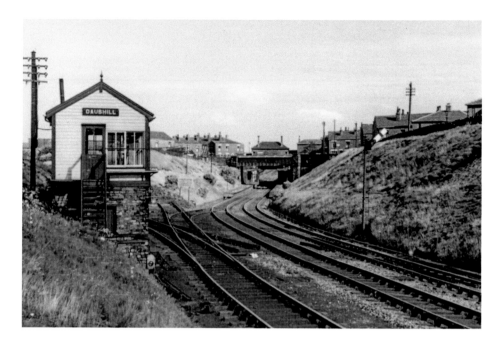

Daubhill Signal Box and Station

Daubhill signal box is shown as it was on 31 August 1952. The original line of the Bolton & Leigh Railway bears off left, while the double-track replacement line of 1885 passes under St Helens Road in the background to enter Rumworth and Daubhill station. The Bolton–Leigh–Kenyon Junction passenger service had ceased to call at the station in March 1952, and was withdrawn altogether in 1954. The signals in both directions are 'pegged', which suggests that the signal box was locked out of use on the Sunday the photograph was taken. Today, the scene has gone entirely, with the cutting filled in and the line becoming part of a wider open space. (*Old photograph: Harold D. Bowtell, modern photograph: Paul Longdon*)

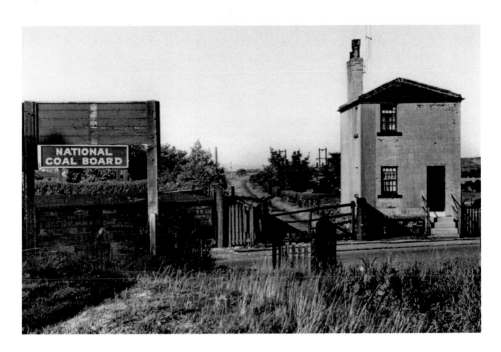

Chequerbent, Westhoughton

Also taken on Sunday 31 August 1952, this photograph again shows the original route of the Bolton & Leigh railway, this time as it crosses what is now the A6 on the level, before descending a steep gradient towards Leigh. The house to the right of the trackbed was at one time a signal and level crossing box, and could date back to the original railway in the 1820s. Today, the house has been altered and extended but still retains the angle to the main road, explained by its original alignment to the railway track. (*Old photograph: Harold D. Bowtell, modern photograph: Don Isherwood*)

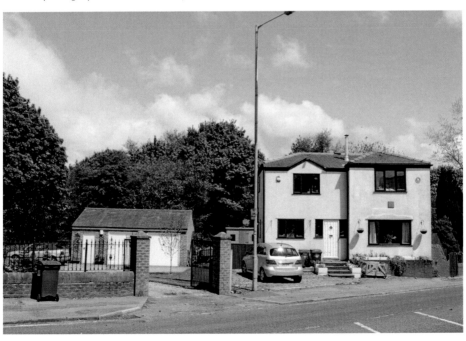

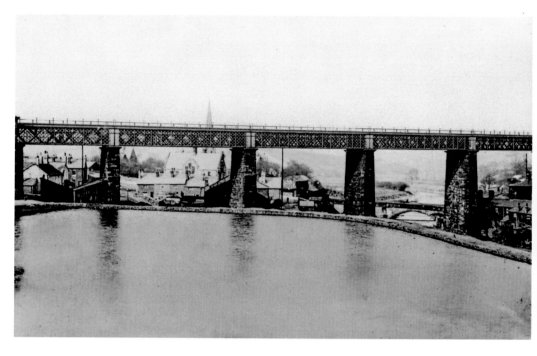

Darcy Lever Viaduct

In 1848, the Lancashire & Yorkshire Railway opened its link between Bolton Trinity Street station and Bury. The Darcy Lever viaduct of eight spans was described at the time by the *Bolton Chronicle* as the first of its kind constructed in England. The line closed in 1970, although the viaduct remains. In the modern photograph, the reservoir has been filled in and has become overgrown. (*Old photograph: John Turner collection, modern photograph: Ray Jefferson*)

The Unexpected

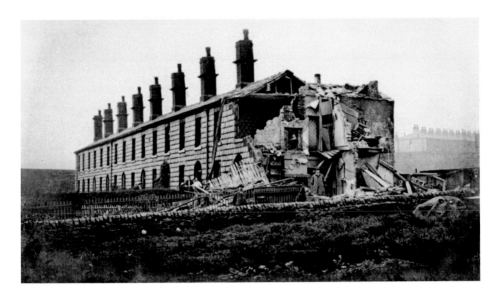

The 1916 Zeppelin Raid

Zeppelin L21 appeared over Bolton on the night of 25 September 1916 and dropped bombs on a variety of areas, including Queen's Park, Acresfield, Old Hall Street, and Kirk Street in the Deane Road area, where thirteen people were killed. The old photograph here shows the damage at Lodge Vale near Mortfield. In this instance, there were three people in the house at the time, but miraculously, none were injured. Standing in front of the house are two men with badges on their coats and hats, who were obviously some kind of official presence. Today, the site lies in the centre of the rugby pitches used by the Bolton Rugby Union Club on Avenue Street. (*Old photograph: Halliwell Local History Society, modern photograph: Ray Jefferson*)

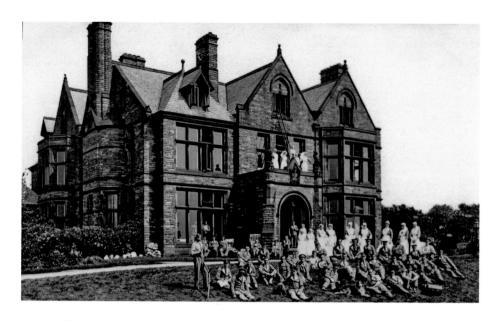

Watermillock, Crompton Way, Bolton

The First World War photograph shows recovering wounded servicemen together with their nurses. A couple of the soldiers look as if they have been interrupted as they were doing some gardening in the grounds. The men's uniforms were blue with white collars and red ties. Watermillock was built as a gentleman's country house in the 1880s, designed by Bradshaw Gass & Hope of Bolton. During the twentieth century, the house has seen a variety of uses, including a home for children escaping the Spanish Civil war, and a social services home. In recent years, it has been converted into a restaurant. Protection as a building of historical or architectural interest came in 1989. (*Old photograph: Derek Eccles collection, modern photograph: Jeff Layer*)

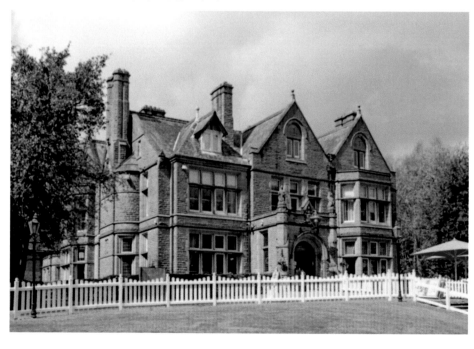

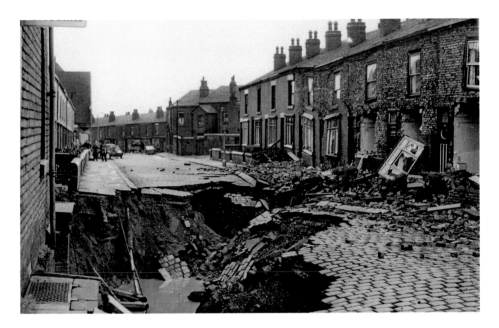

Fylde Street, Moses Gate

On the morning of 12 September 1957, a sewer collapse in Moses Gate caused 121 houses to be evacuated. Luckily, there had been some warning as the road had started to sag and people were asked to be ready to move. When the damage was finally assessed, nineteen houses had to be demolished because they were beyond repair. The collapse was caused by ground water movement around a sewer originally laid in 1867 on silt rather than clay. The news travelled around the world and the comedienne, Hylda Baker, held a fundraising concert at the Theatre Royal in Bolton. Today, the street no longer has the same urban character, with a mixture of uses being represented. (*Old photograph: Bolton Archives, modern photograph: Judy Bell*)

Works in Progress

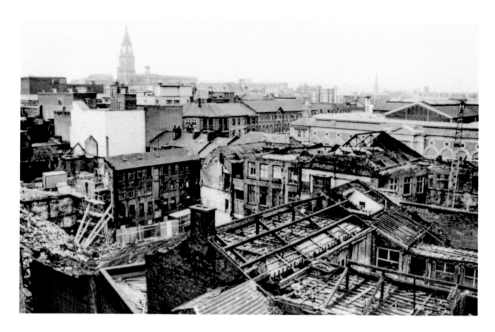

Demolition on Bridge Street, Bolton

In February 1992, the former Co-operative Society store on Bridge Street was well on the way to complete demolition, to be replaced by modern units, including an Argos. The view is from the top floor of the Bow Street multistorey car park, looking towards the town hall. In the middle distance on both the old and the new images, the exterior of the Market Hall can be seen, although since the earlier picture this too has undergone a complete refurbishment of the interior, with the replacement of market stalls by modern shops. (*Old photograph: Ray Jefferson, modern photograph: Bob Holden*)

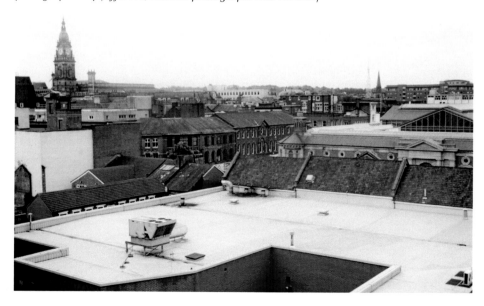

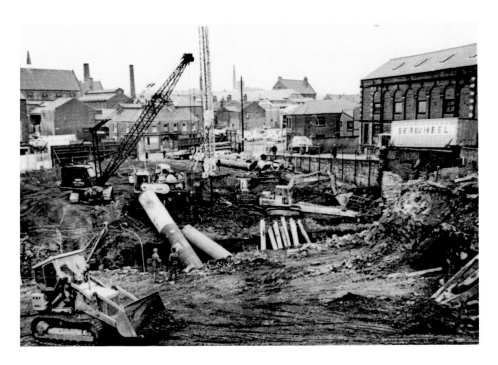

Bow Street Multistorey Car Park, Bolton

The Bow Street multistorey car park was constructed during 1968, and the photographer caught the workmen in the act of culverting the River Croal prior to the construction of the car park itself. On the right can be seen the Crown Corn Mill, which was demolished in the 1980s. One of the few buildings in the older photograph that is still standing today is All Saints church, on the extreme left of the picture, now the Ukrainian Catholic church. (*Old photograph: Geoffrey A. Whitehead, modern photograph: Alan Bromiley*)

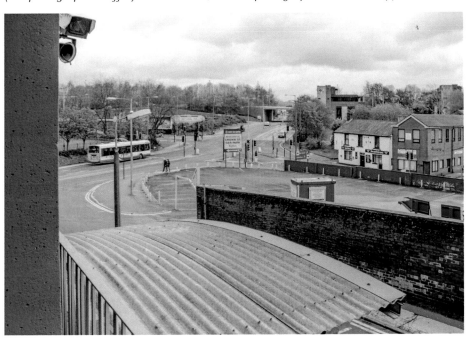

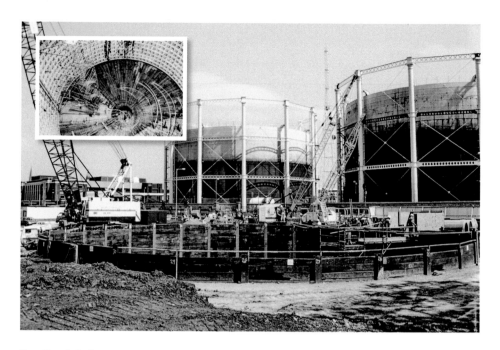

Spa Road, Bolton

Drainage systems dating from the Victorian era are usually inadequate for modern flows as towns expand, and are very expensive and difficult to upgrade or replace. One solution is to delay the surge of water that rushes down the pipes after a rainstorm by diverting the flow into storage tanks built upstream of the substandard pipes. One such tank is under construction in Spa Road in July 1991, and the insert picture shows the cavernous interior. Today, the tank is concealed underground and the only evidence of the structure is the brick building that allows access for maintenance. (*Old photographs: Ray Jefferson, modern photograph: Phil Durkin*)

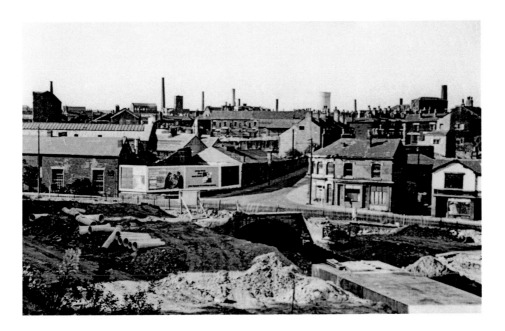

Church Wharf and St Peter's Way

A traffic survey in 1960 suggested that congestion on the north to south A666 would require a new bypass – which became St Peter's Way. Before the road could be constructed, two lengths of the River Croal had to be placed in a culvert. The top photograph shows part of the northern culvert under construction at Church Wharf in 1968. The 600-yard culvert cost £65,000, and the 12 foot by 10 foot rectangular structure included a safety margin to allow debris to pass in the time of flood. The advertising hoarding says 'Snap into that seatbelt', front seatbelts being a legal requirement from 1967. Today, the area is a green space below the parish church. (*Old photograph: Halliwell Local History Society, modern photograph: Neil Pilkington*)

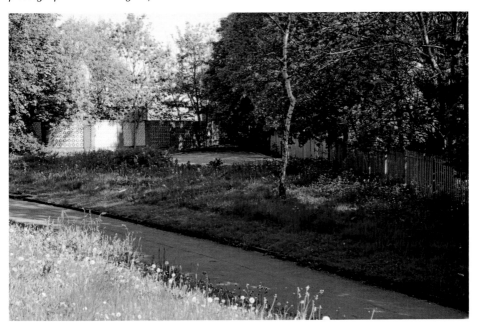

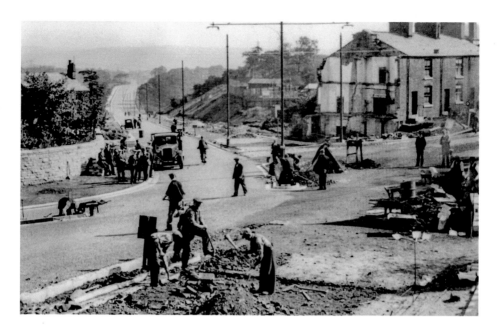

Moss Bank Way/Halliwell Road

Moss Bank Way opened on 9 December 1938 at a cost of £105,000 for the 2½ miles involved. It was the last length of bypass to be completed in Bolton before the opening of St Peter's Way in 1971. The work is well underway in the older picture, which shows the junction at Halliwell Road. Shovels, pickaxes and wheelbarrows were the main construction tools. The junction has been remodelled again in recent years, with the road becoming considerably wider and taking in more land on the northern side of the junction. The modern view also shows the neglected public artwork near the camera, made in conjunction with local children as part of the Bolton City Challenge programme. (*Old photograph: Halliwell Local History Society, modern photograph: Jeff Layer*)

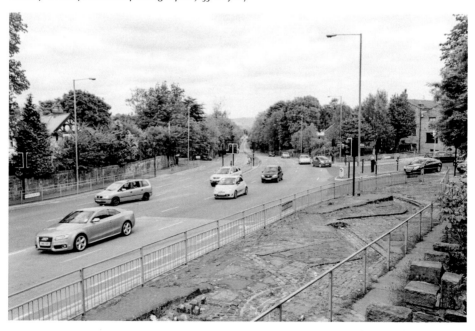

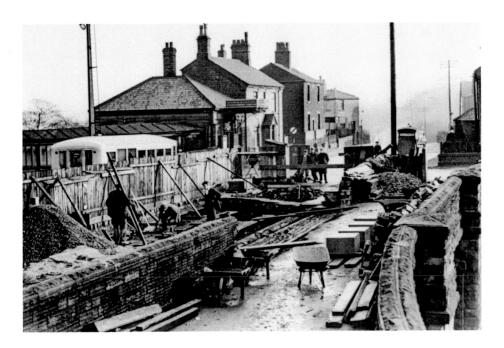

Chequerbent Station

In keeping with the bus passing the works, this picture dates from 1937. It shows the rebuilding of the bridge taking Manchester Road over the railway at Chequerbent station, near Westhoughton. The station was opened in 1885, when the railway alignment was diverted from what had originally been a level crossing about 100 yards further on, adjacent to the house seen at an angle to Manchester Road. In the modern view, there is little indication of the bridge at this point apart from a parapet wall, and the station and railway have both gone. (*Old photograph: Bolton Archives, modern photograph: Ray Jefferson*)

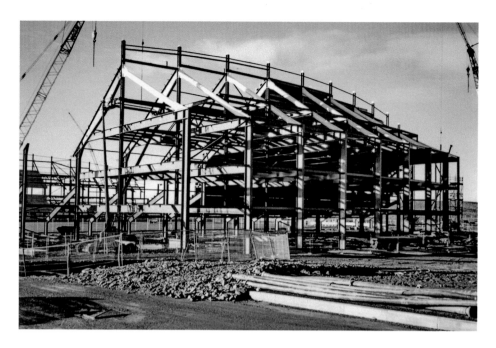

The Reebok Stadium

Following the Taylor Report on the need for all-seater football stadia, it became necessary to find a new location for the old Manchester Road ground of Bolton Wanderers Football Club. The location chosen was on the Bolton/Horwich boundary, and stimulated the large Middlebrook retail and leisure development in the 1990s. A combination of grants and cross funding from the other development, helped produce the iconic ground shown in the modern photograph. Since the initial opening, further development has resulted in more offices, an arena for tennis nearby and a hotel embedded in the football ground itself. (*Old photograph: Ray Jefferson, modern photograph: Ray Jefferson*)

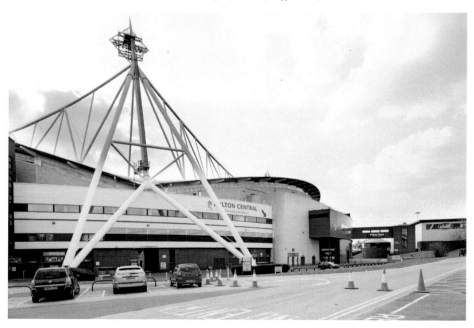